The Town of CELEBRATION

Editor and Photography
Jim Siegel

Design and Layout
Scott Zwiebel

© 2012 Jim Siegel
Published by Thunderbird Publishing

All rights reserved. No part of this publication may be reproduced, stored in a retrieval system, or transmitted in any form or by any means, electronic, mechanical, photocopying, recording, or otherwise, without prior written permission of the author or publisher.

The information in this publication is true to the best of our knowledge. All comments or recommendations, whether explicit or implicit, are made without any guarantee on the part of the author or publisher, who also disclaim any liability incurred in connection with the use of the images, data or specific details contained herein.

The author and publisher recognize that some words, products, brands and designations, for example, mentioned or pictured herein are the property of the trademark holder. This is not an official publication of those companies. The town name "Celebration" and the town logo are registered to or otherwise owned or controlled by the Walt Disney Company and/or The Celebration Company. Images contained in this publication were captured on or from public property or on property publicaly accessible without any special permissions, passwords, or keys required, except in certain situations (such as but not limited to building interiors and certain individuals) for which prior approval was obtained for access and inclusion in this publication.

This publication was created at the request of and approved by the Celebration Residential Owners Association (CROA), Celebration, FL 34747. CROA, its officers, staff, and members disclaim any liability incurred in connection with the use of the contents or specific details contained herein.

Library of Congress Cataloging-in-Publication data available.

ISBN-13: 978-0615549965 (Thunderbird Publishing)

ISBN-10: 0615549969

Contact Thunderbird Publishing at
ThunderbirdPublishing@gmail.com

Prints of the images contained herein are available for private use only and may not be re-sold or used commercially.
Go to: http://celebrationjim.smugmug.com/ThunderbirdPublishing/

For permission to use any images for commercial use, please email *ThunderbirdPublishing@gmail.com*

The Town of CELEBRATION

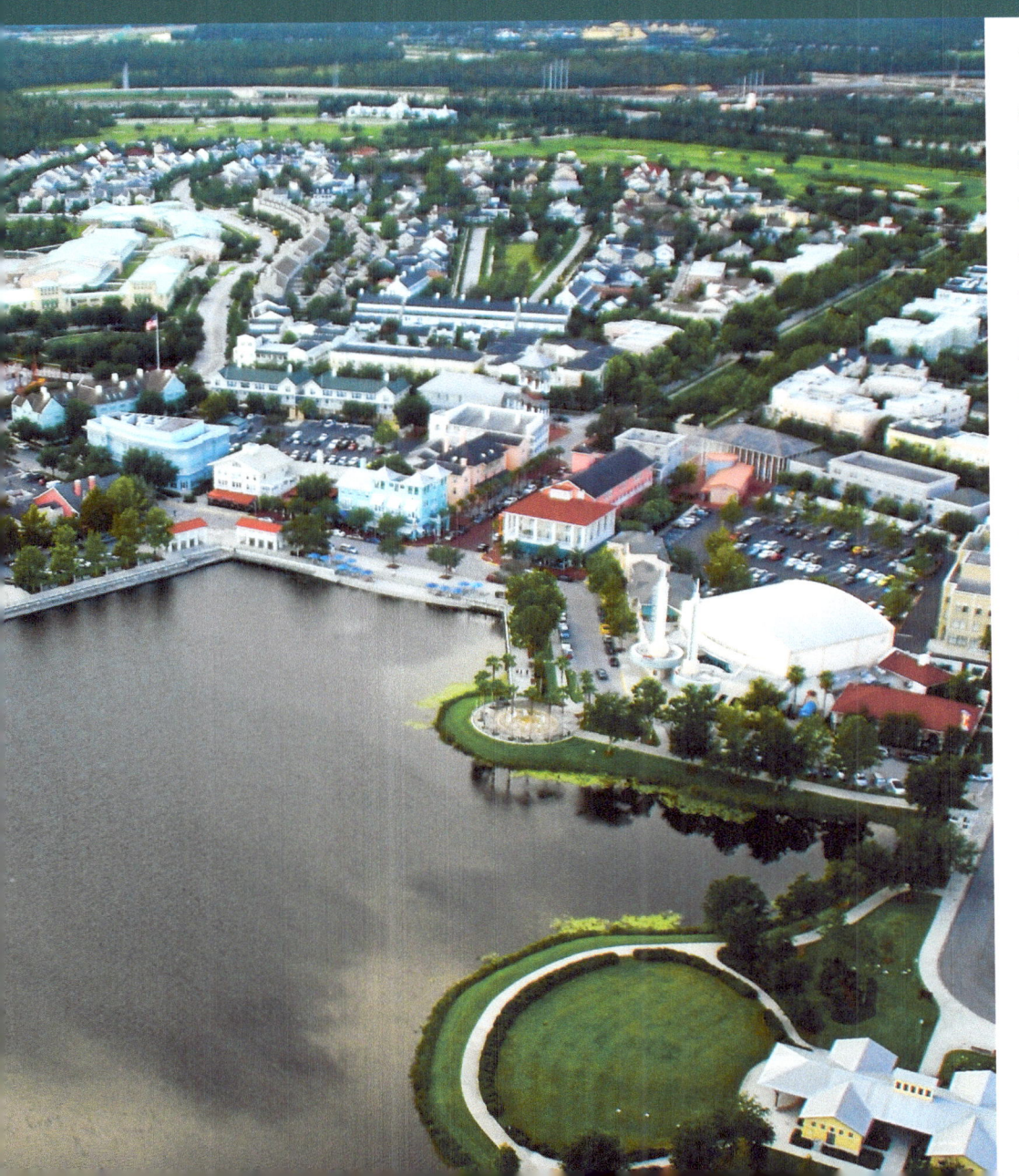

"Celebration's planners envisioned a community reminiscent of the quaint villages that dot New England's landscape. They wanted a downtown, parks, playgrounds and a school, all within walking distance of the homes. They wanted sidewalks and picket fences, a town not unrelated to Disney World's Main Street USA, just a mile or so away. They wanted to bring back a way of life lost when suburbs appeared and cars became the only way to get to distant stores, school and work."

"At Celebration, Some Reasons to Celebrate,"
New York Times,
March 7, 1999

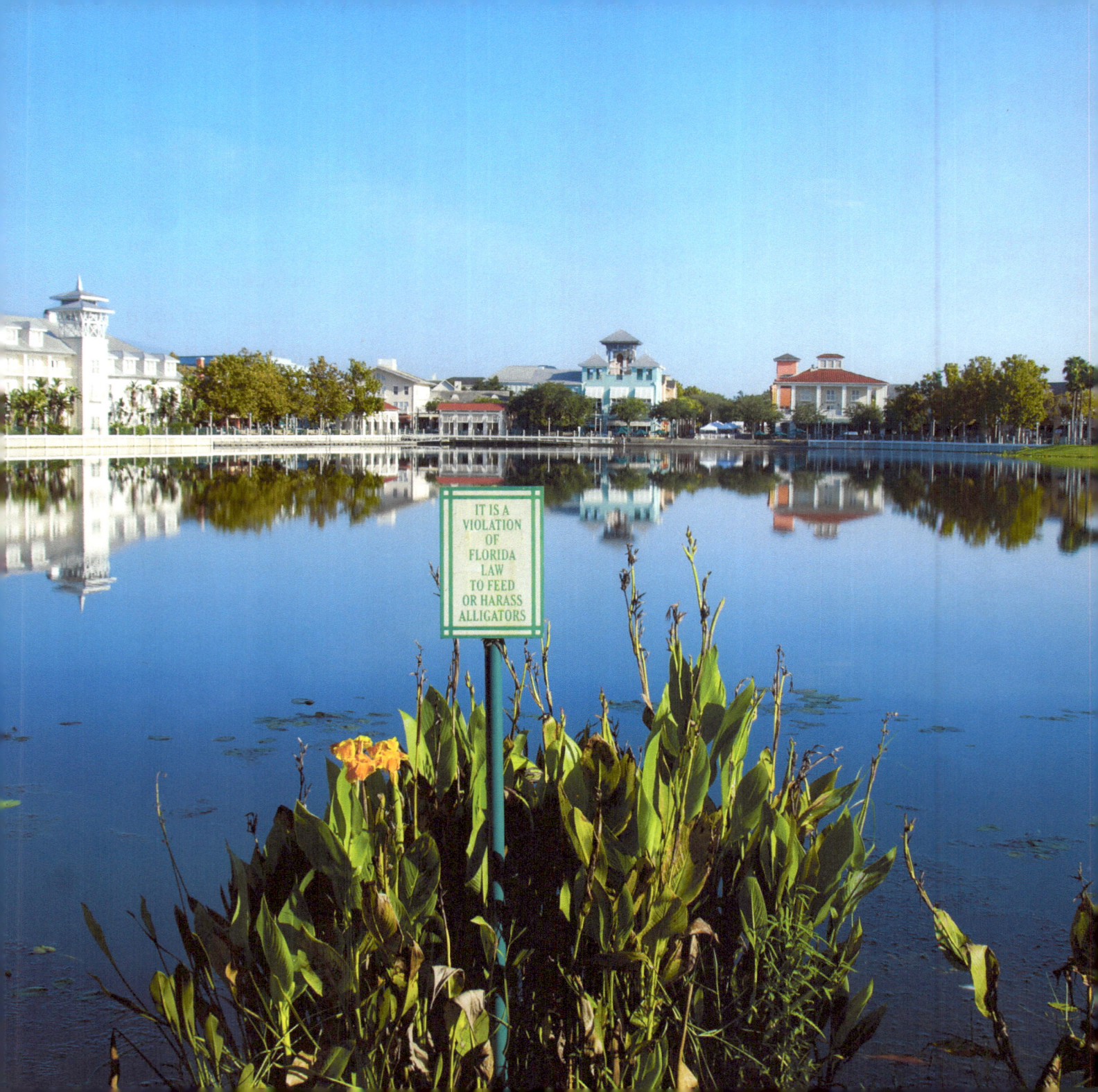

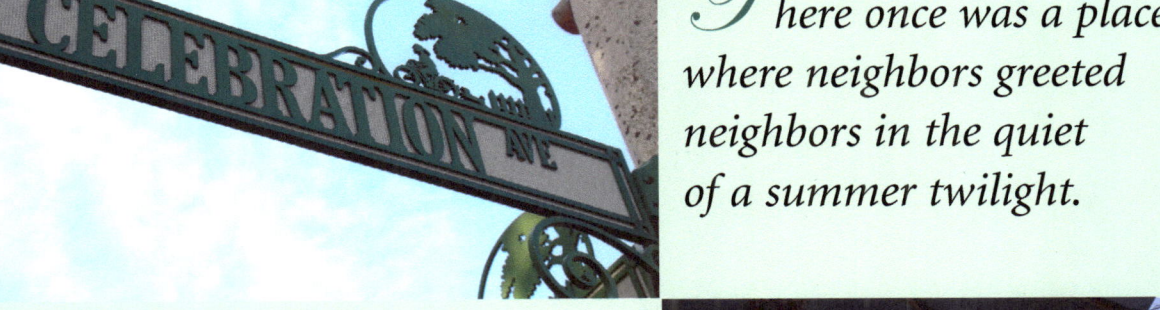

*T*here once was a place where neighbors greeted neighbors in the quiet of a summer twilight.

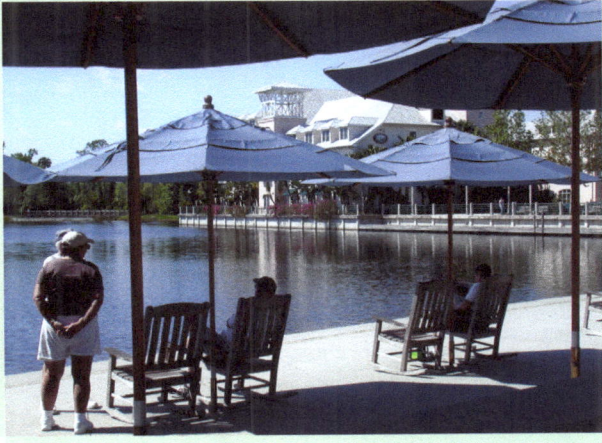

*W*here children chased fireflies.

And porch swings provided easy refuge from the care of the day ... remember that place?

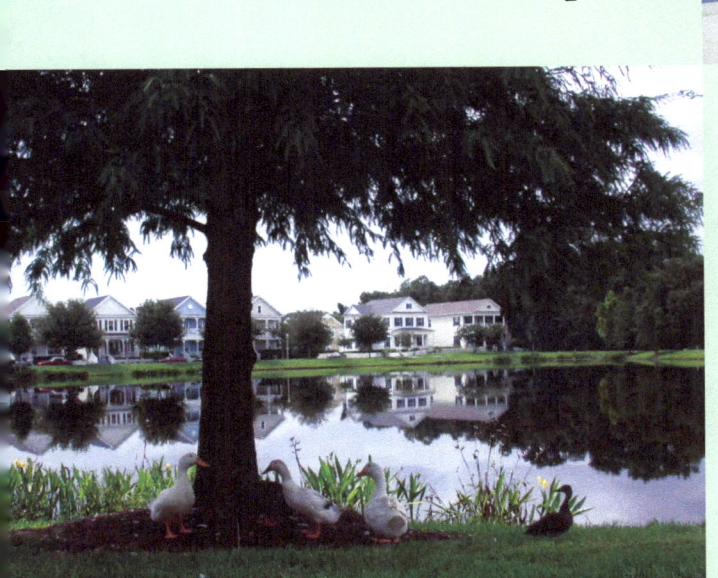

*P*erhaps from your childhood, Or maybe just from stories. It held a magic all its own. The special magic of an American hometown.

From an initial Celebration brochure, circa 1996

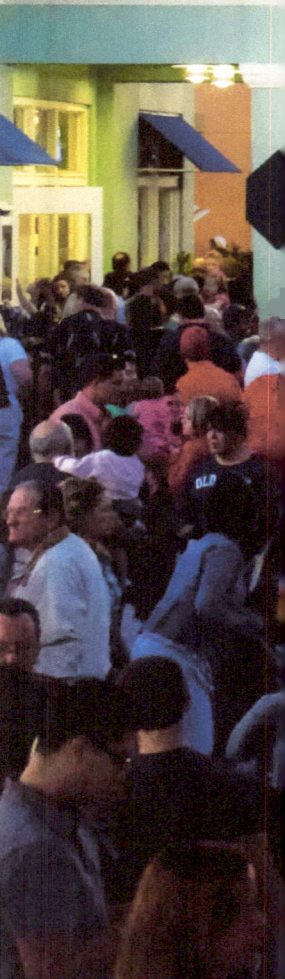

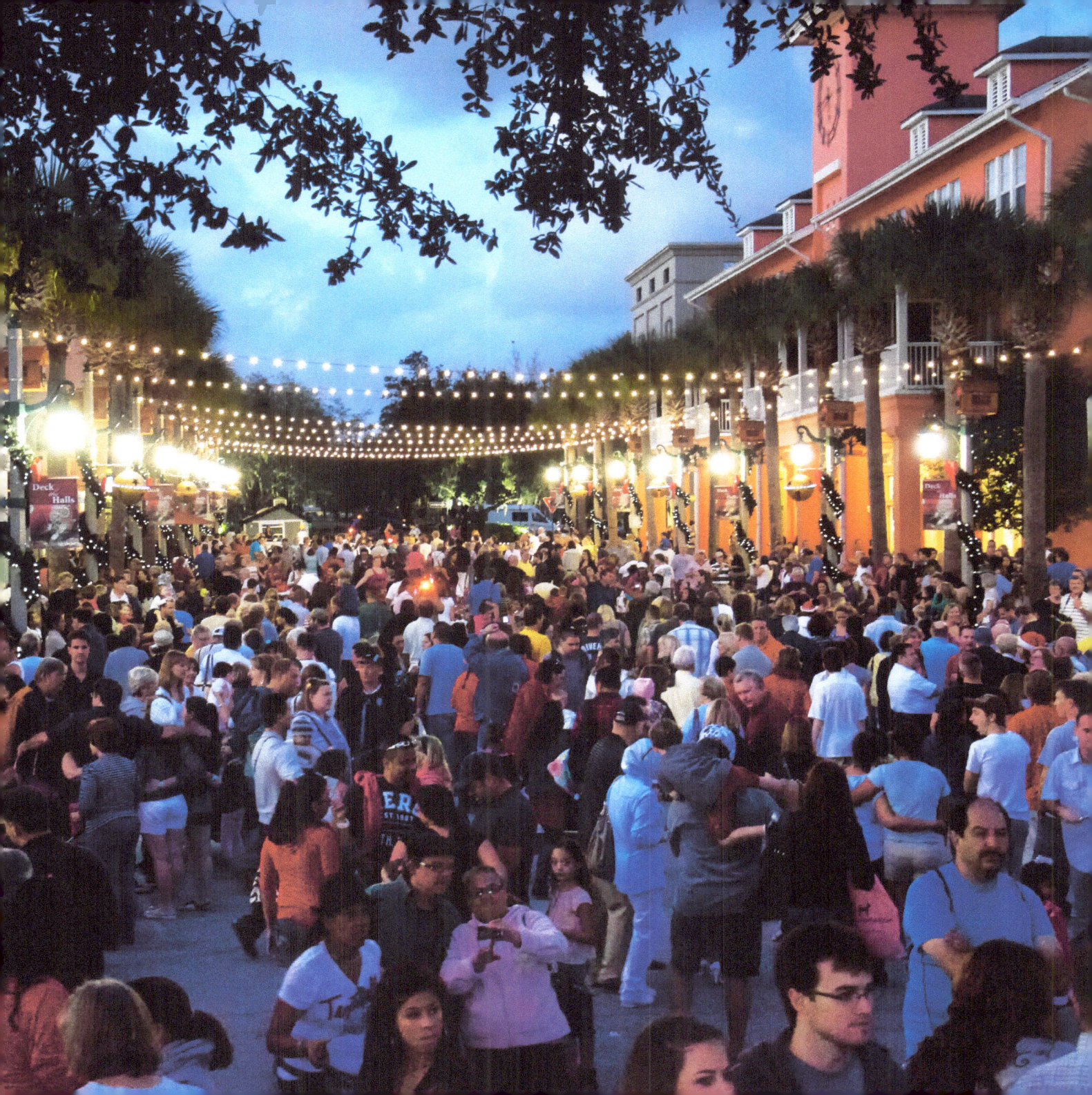

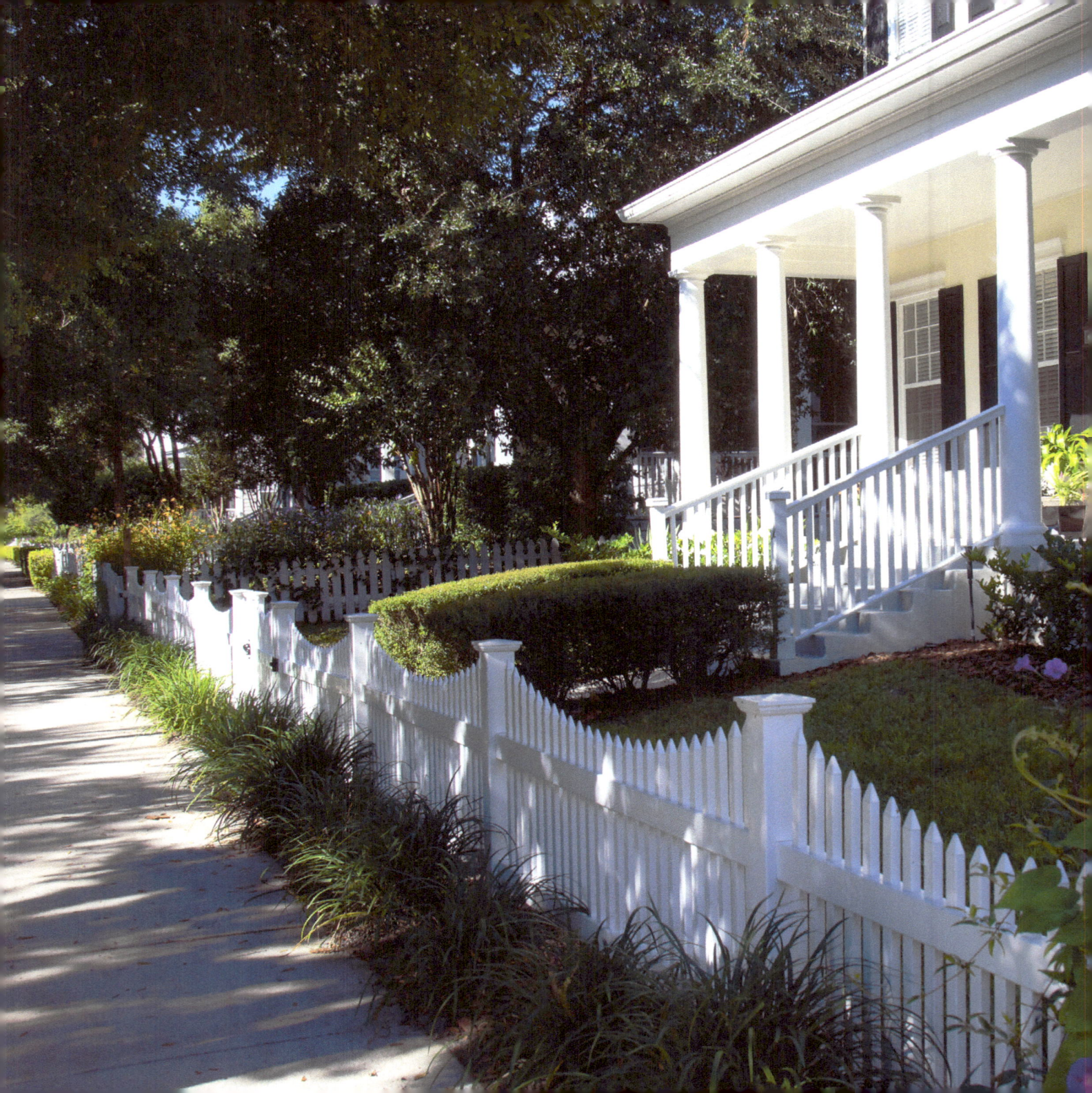

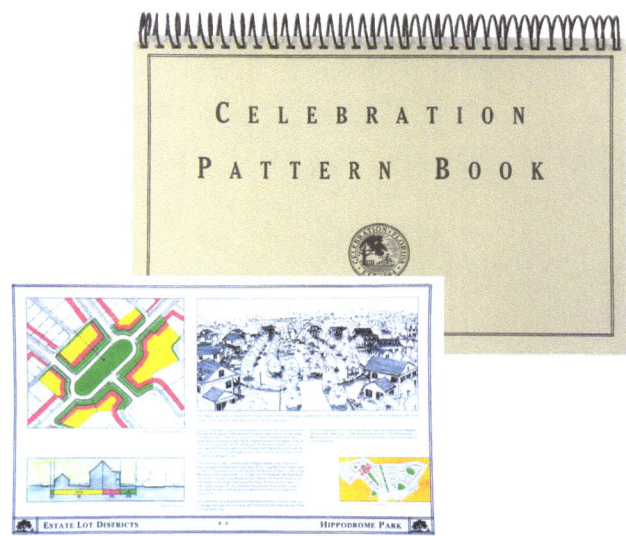

Planners resurrected the Pattern Book concept that builders used in this country until the Second World War to provide an 80-page collection of design details and methods used by individual designers to create a wide range of houses while maintaining the traditional character of the town.

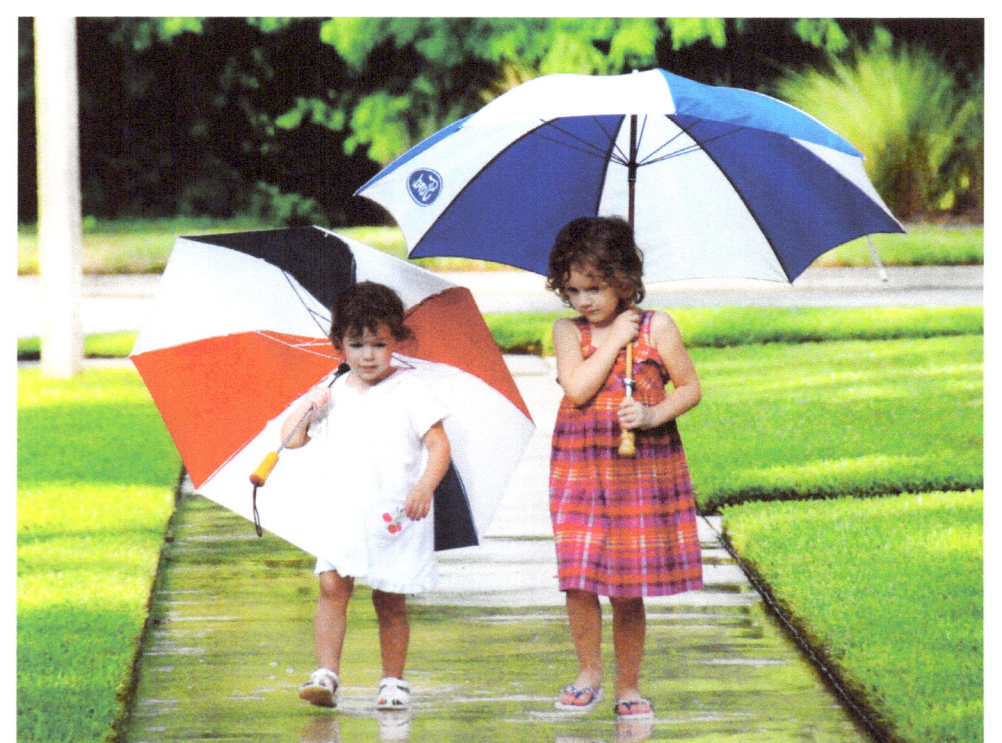

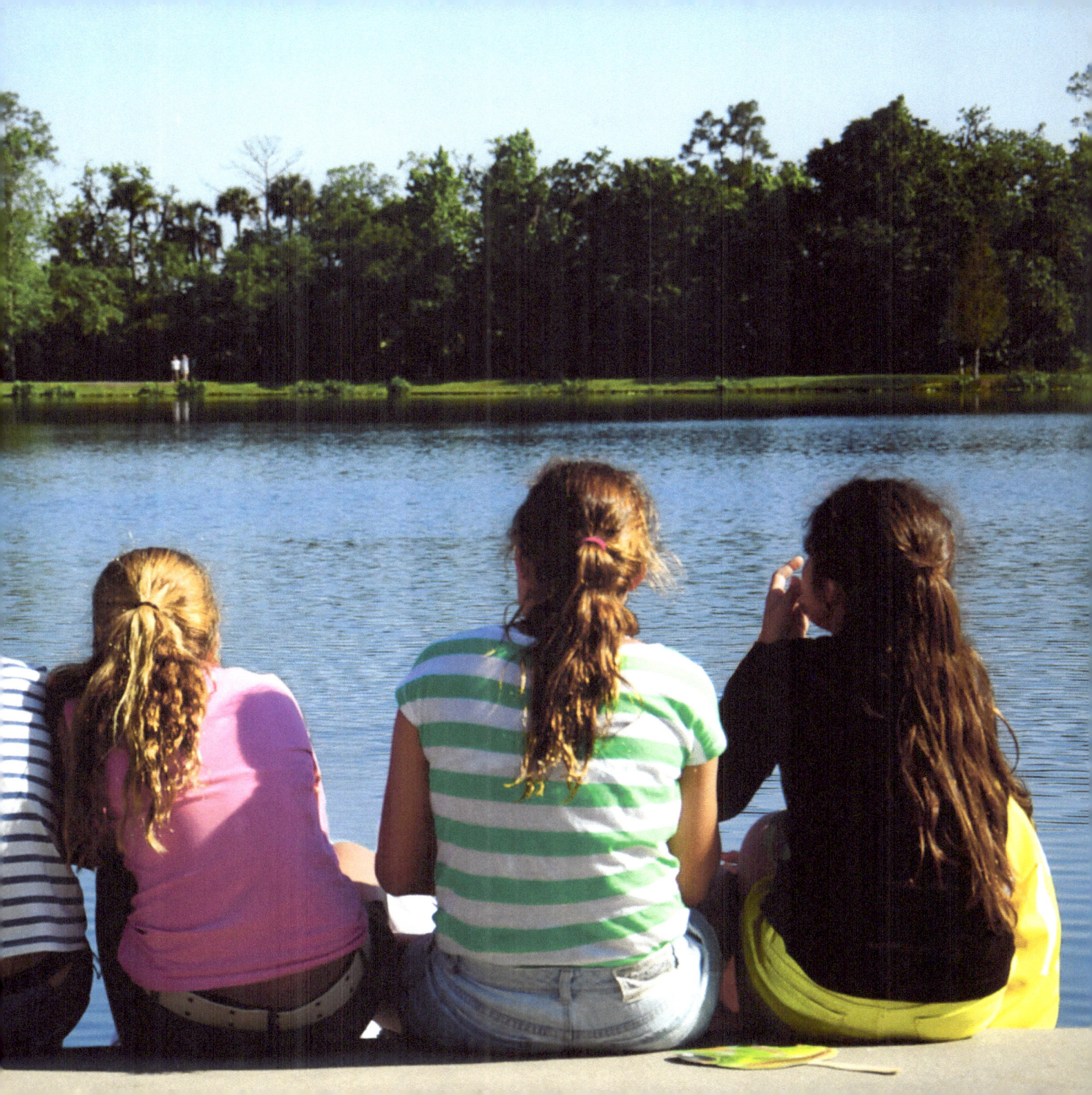

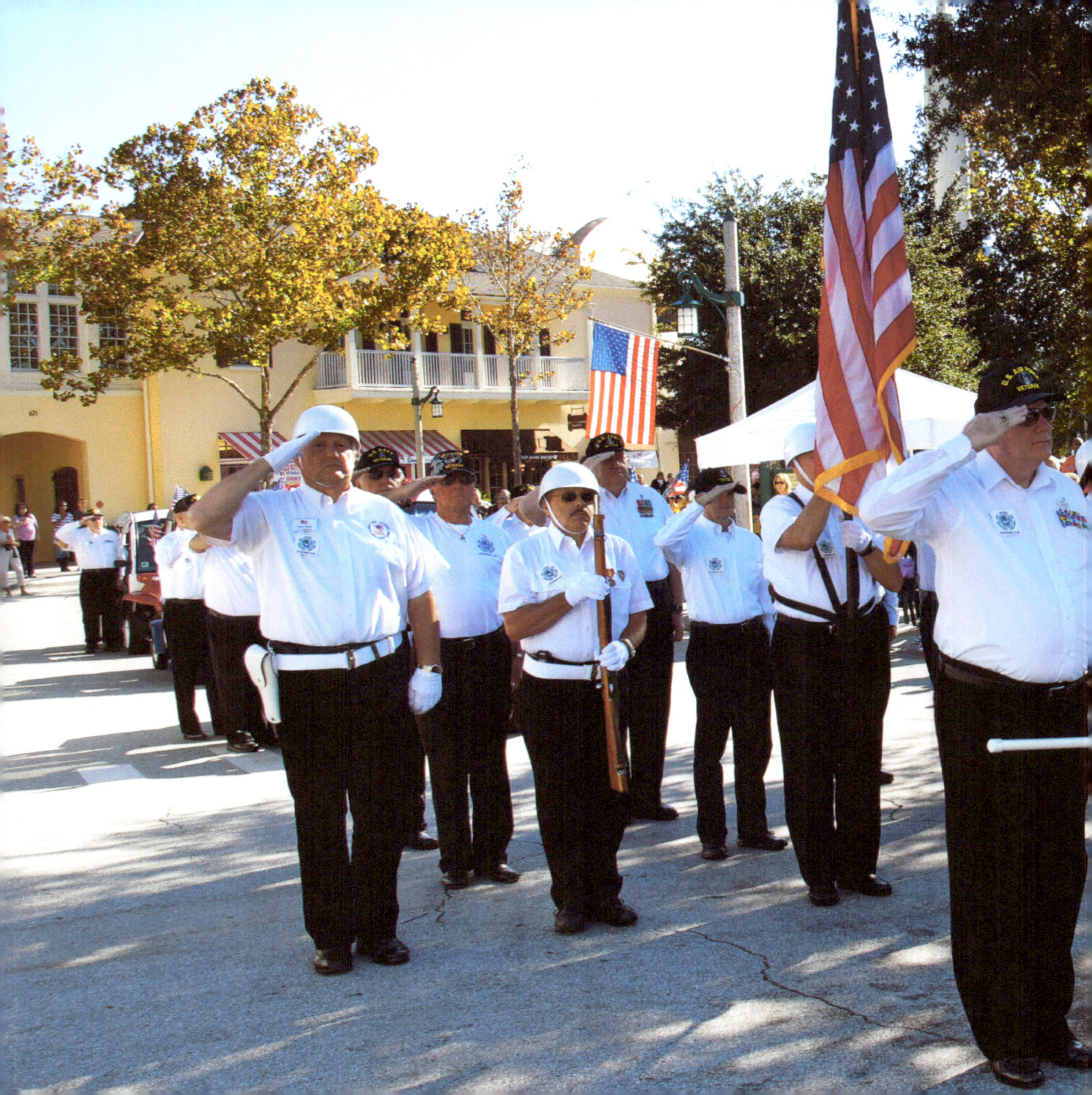

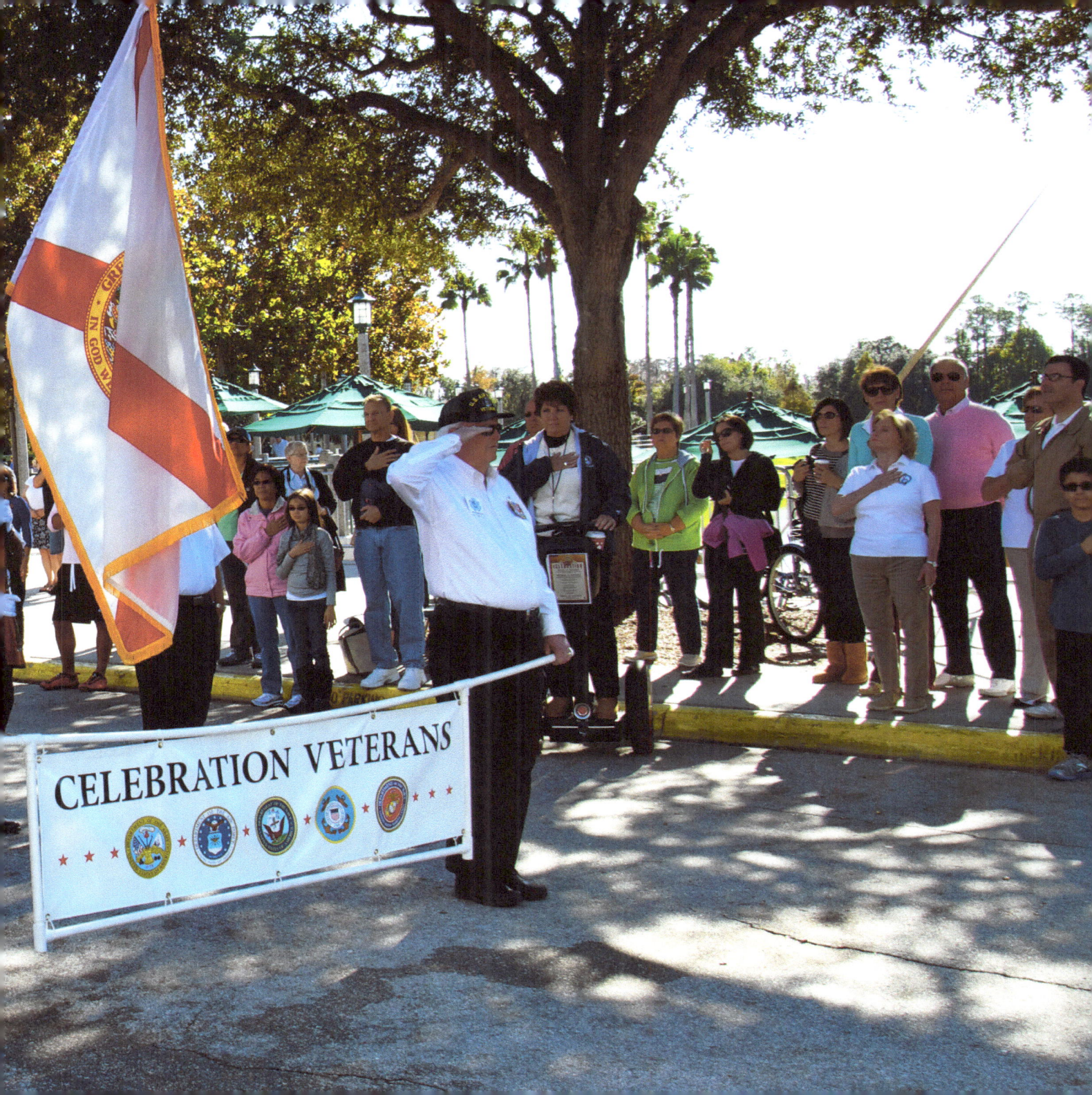

PROUDLY WE SERVED
COL W MCCHESNEY USAF
COL R MCCHESNEY USAF
CDR R MCCHESNEY USN
CPT S MCCHESNEY USAF
COL J MCCHESNEY USAF

Daddy xxxooo

aloha nui aloha
With Love
Jon

SGT
3ID
USA

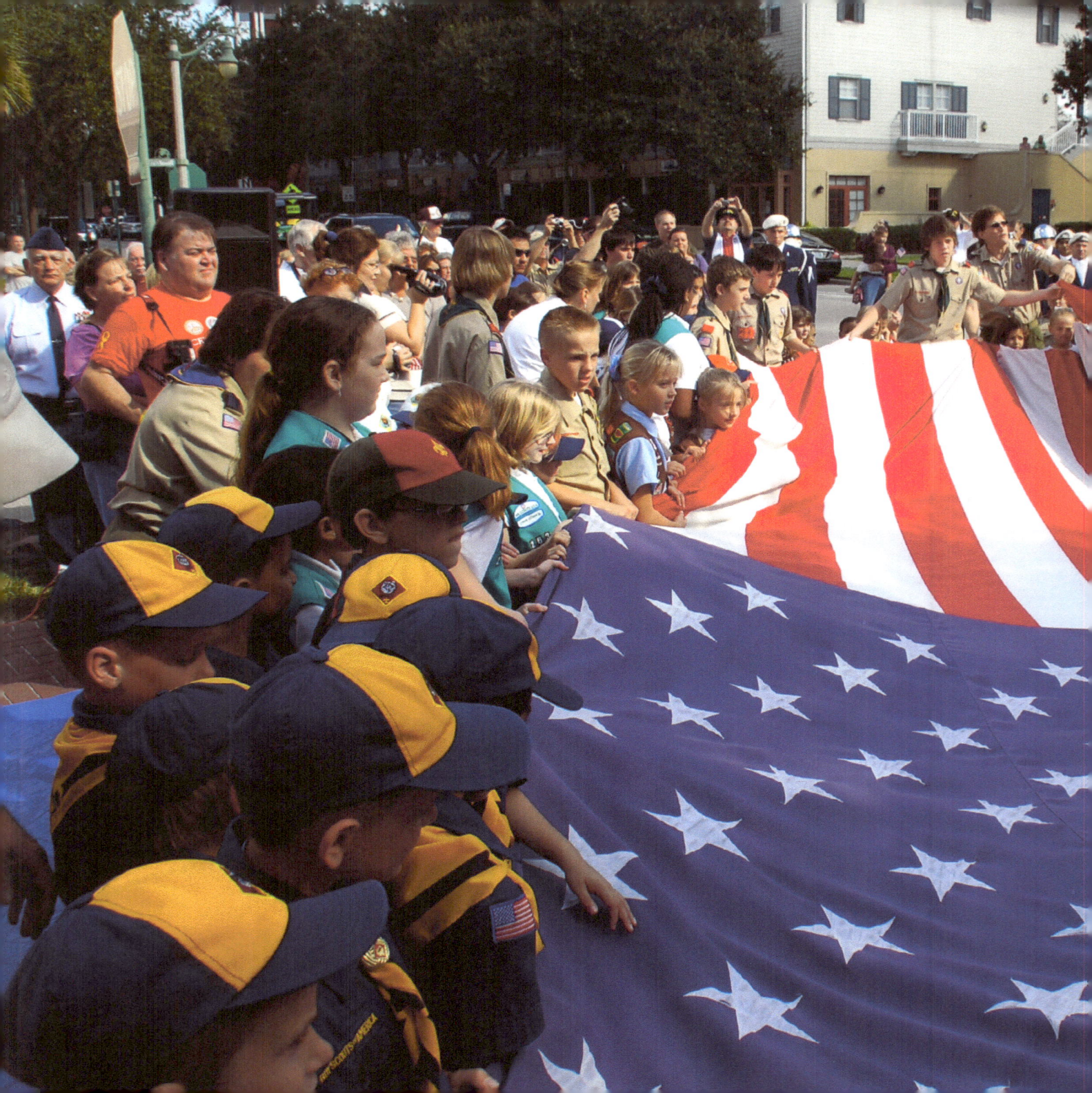

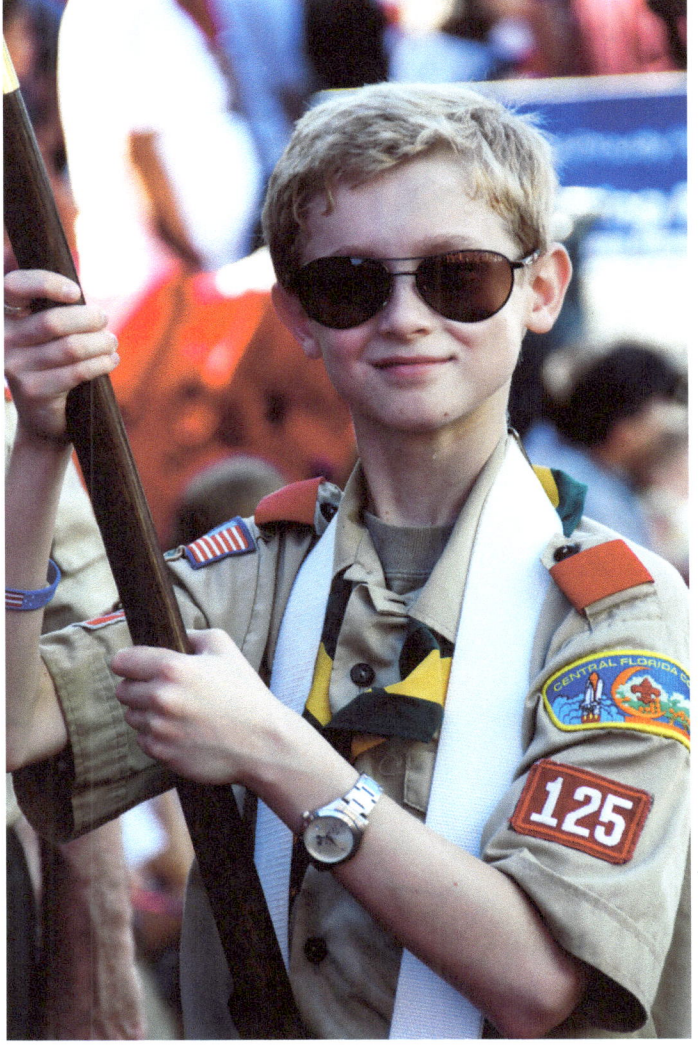

Simon Alexander Sharp
1992–2007
"Once an Eagle...always an Eagle"

This plaque is in memory of Simon Sharp who initiated the Celebration Veteran's Memorial as his Eagle Scout Project. After raising $15,000 and coordinating the initial design, Simon was diagnosed with leukemia. Fifteen months later, Simon received his Eagle Scout Award the day before he passed away. Prior to his death, Simon requested his friend and fellow Scout, Bradley Trowbridge to continue the project. After Simon's death, Scouts, Veteran's, and patriotic citizens from all over the United States generously donated so that the Memorial could be completed.

Simon was posthumously presented the James E. West Award by the Boy Scouts of America, which honors outstanding Eagle Scout Projects. The Celebration Veteran's Memorial was dedicated on November 15th, 2008.

"The legacy of heroes is the memory of a great name and the inheritance of a great example." –Benjamin Disraeli

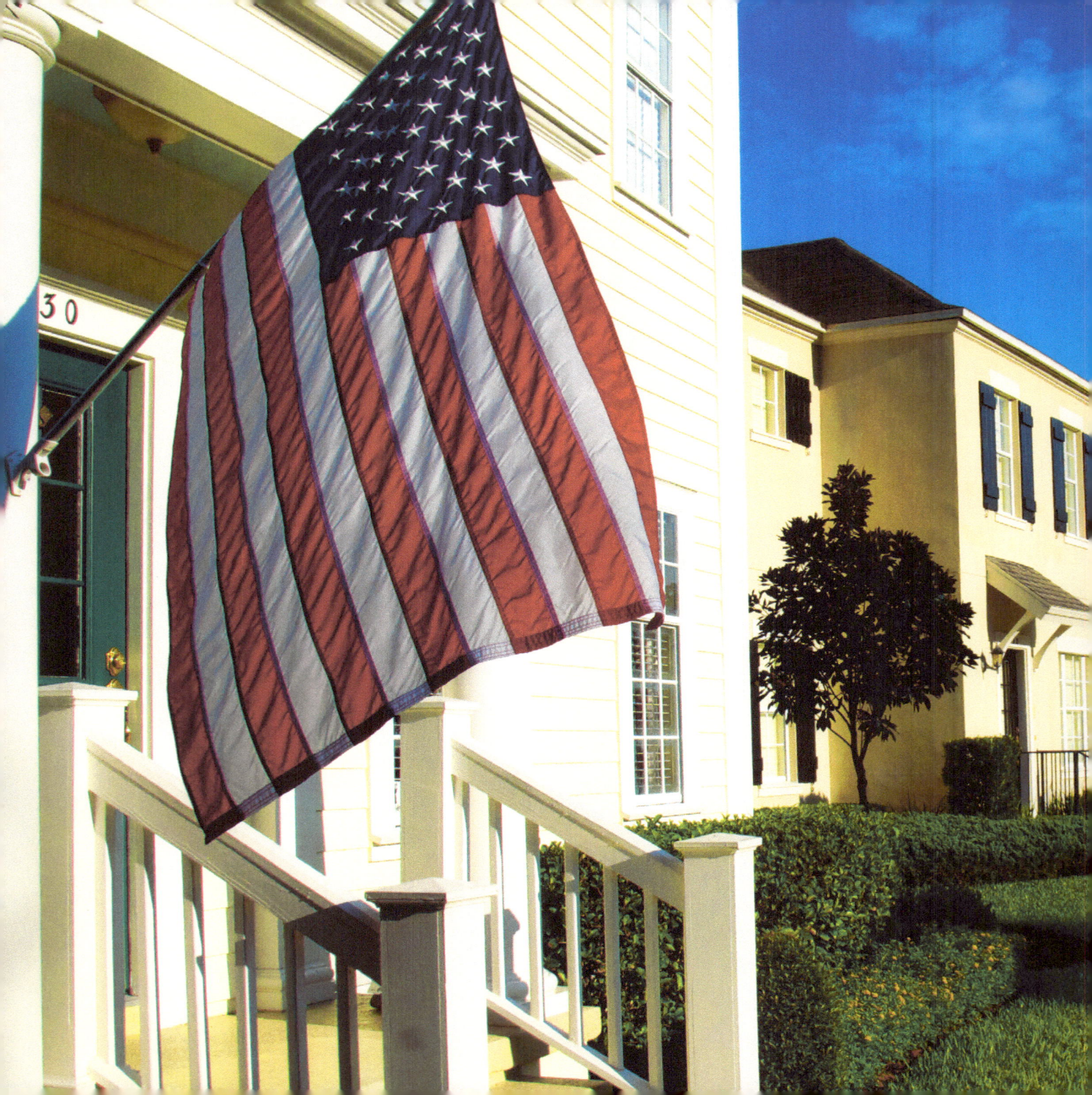

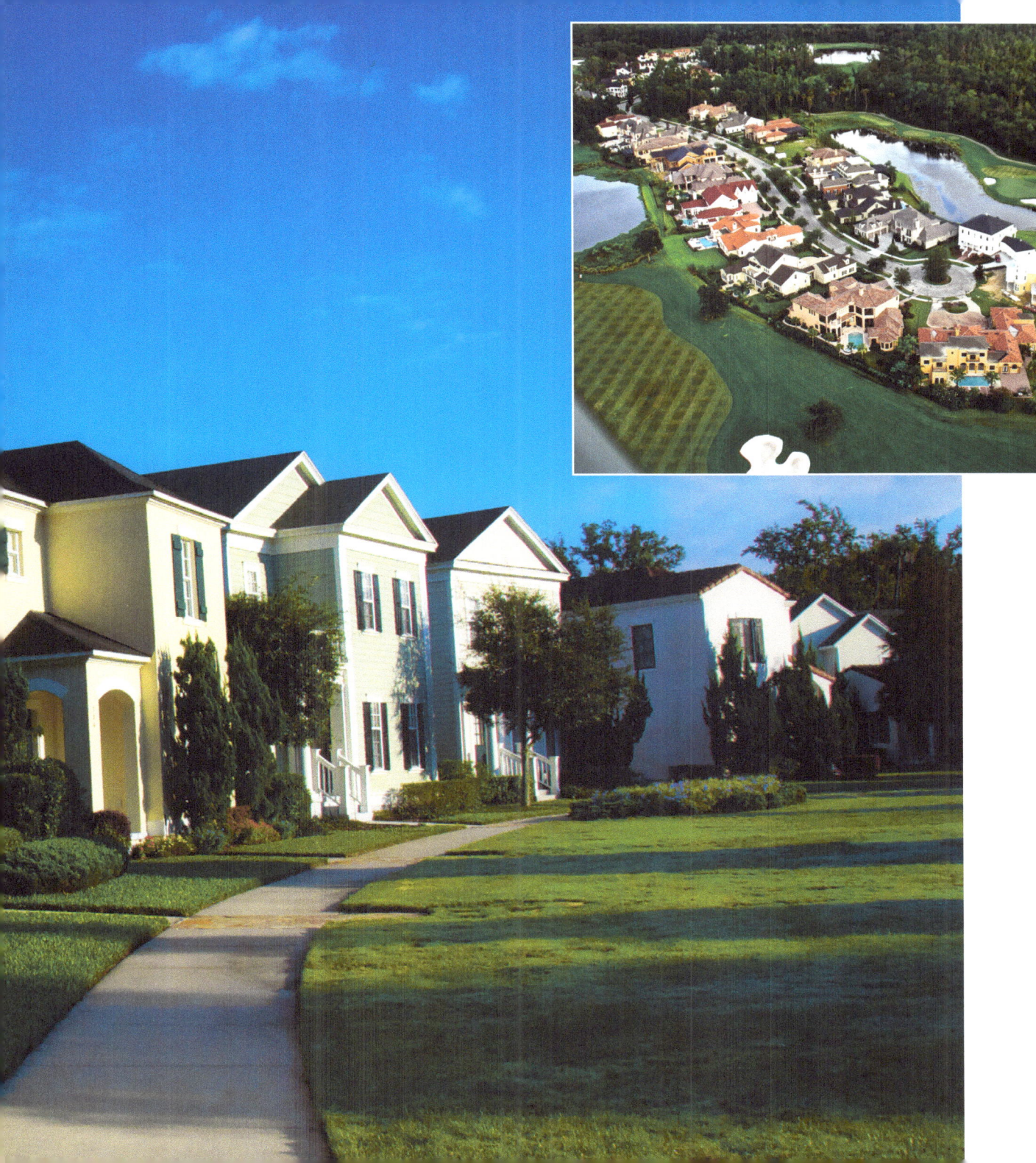

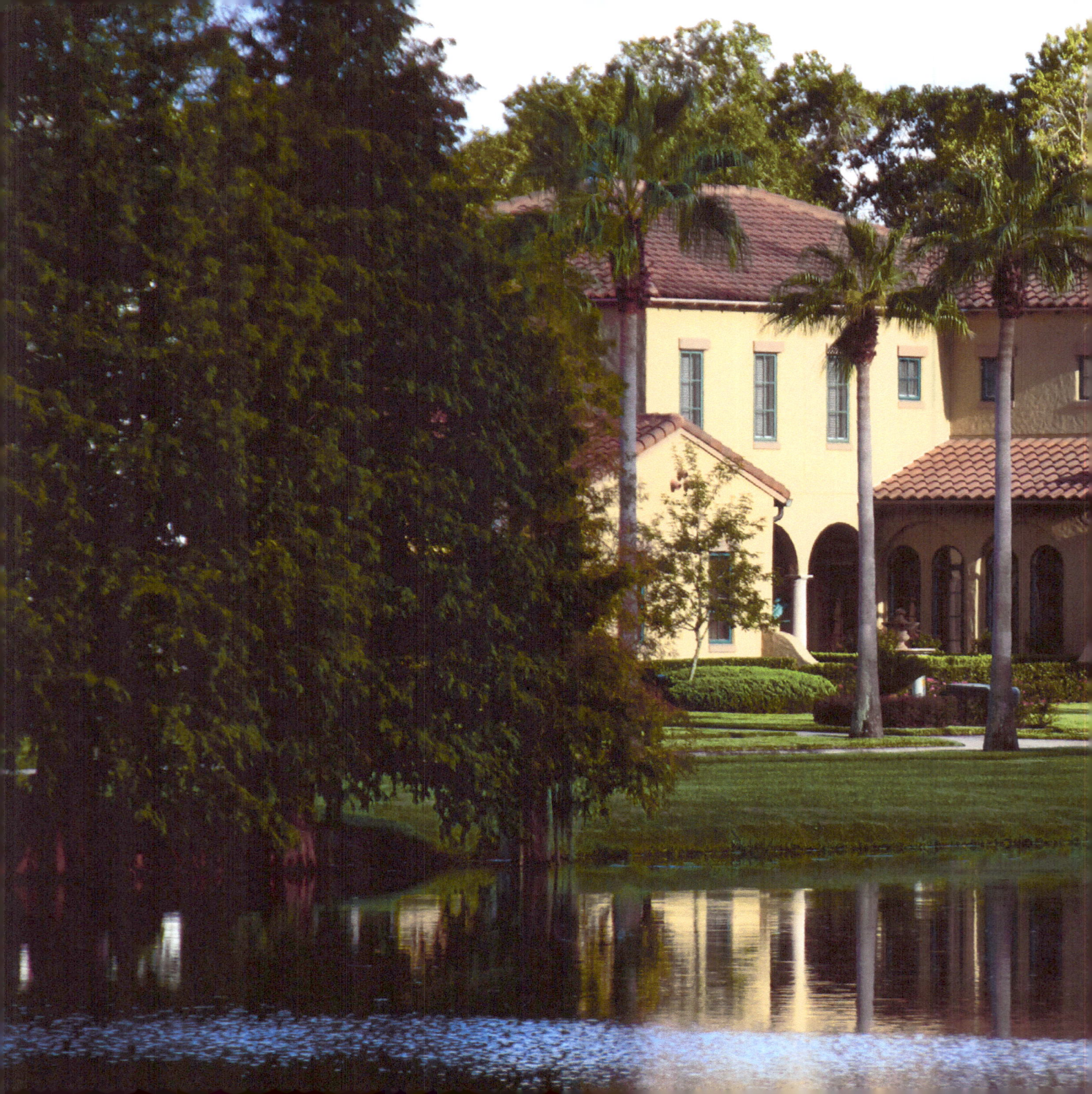

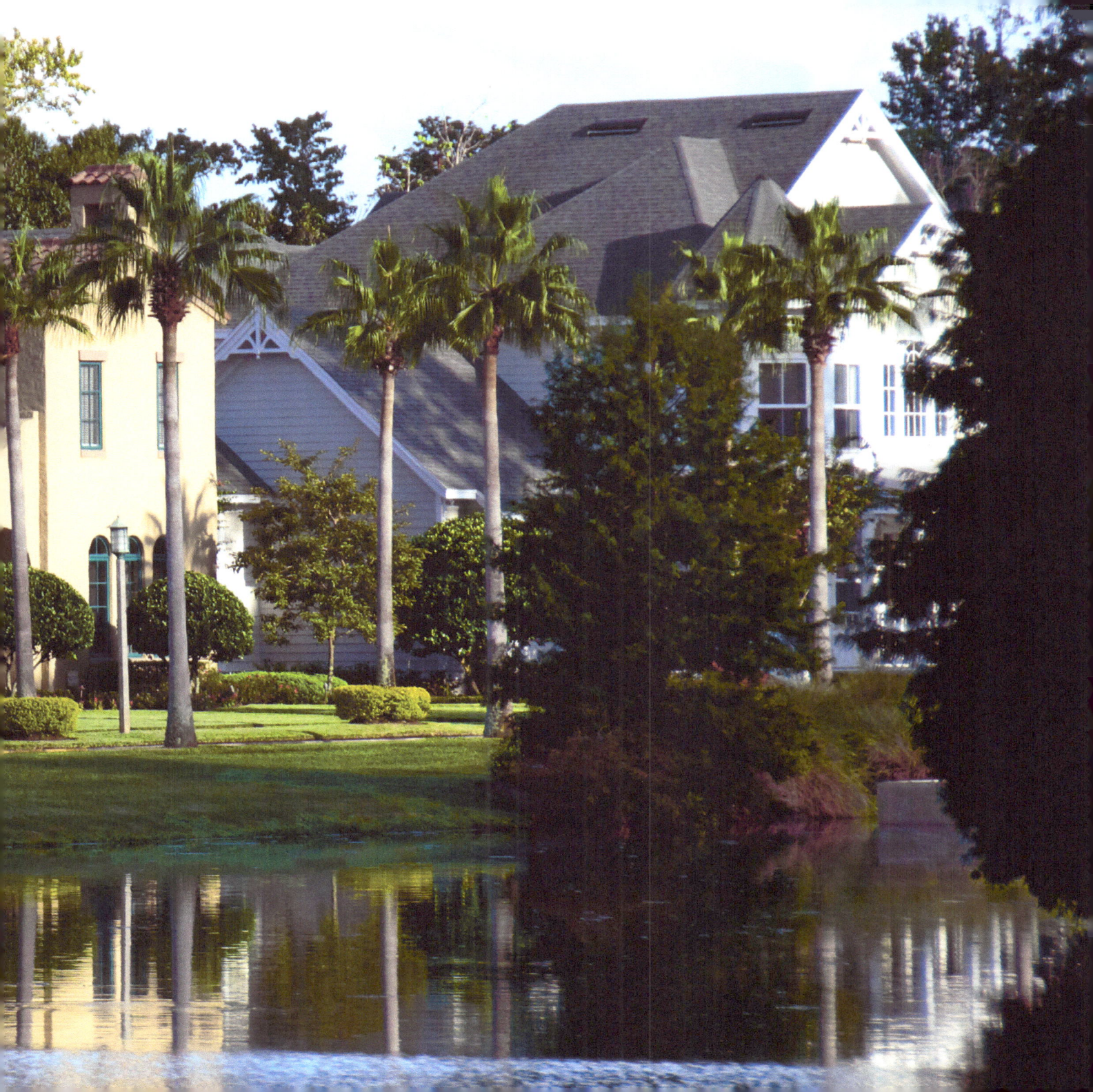

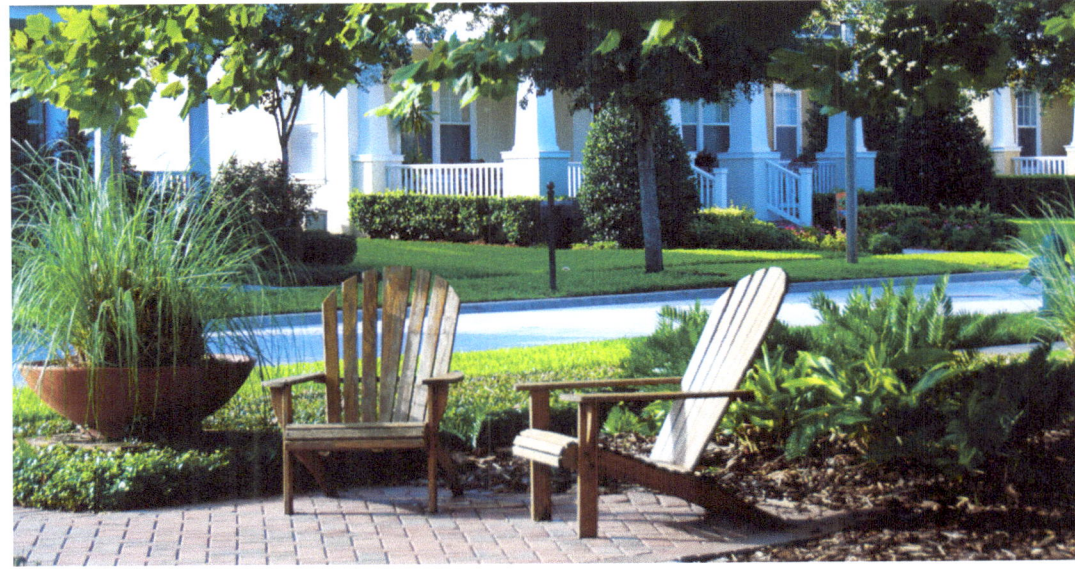

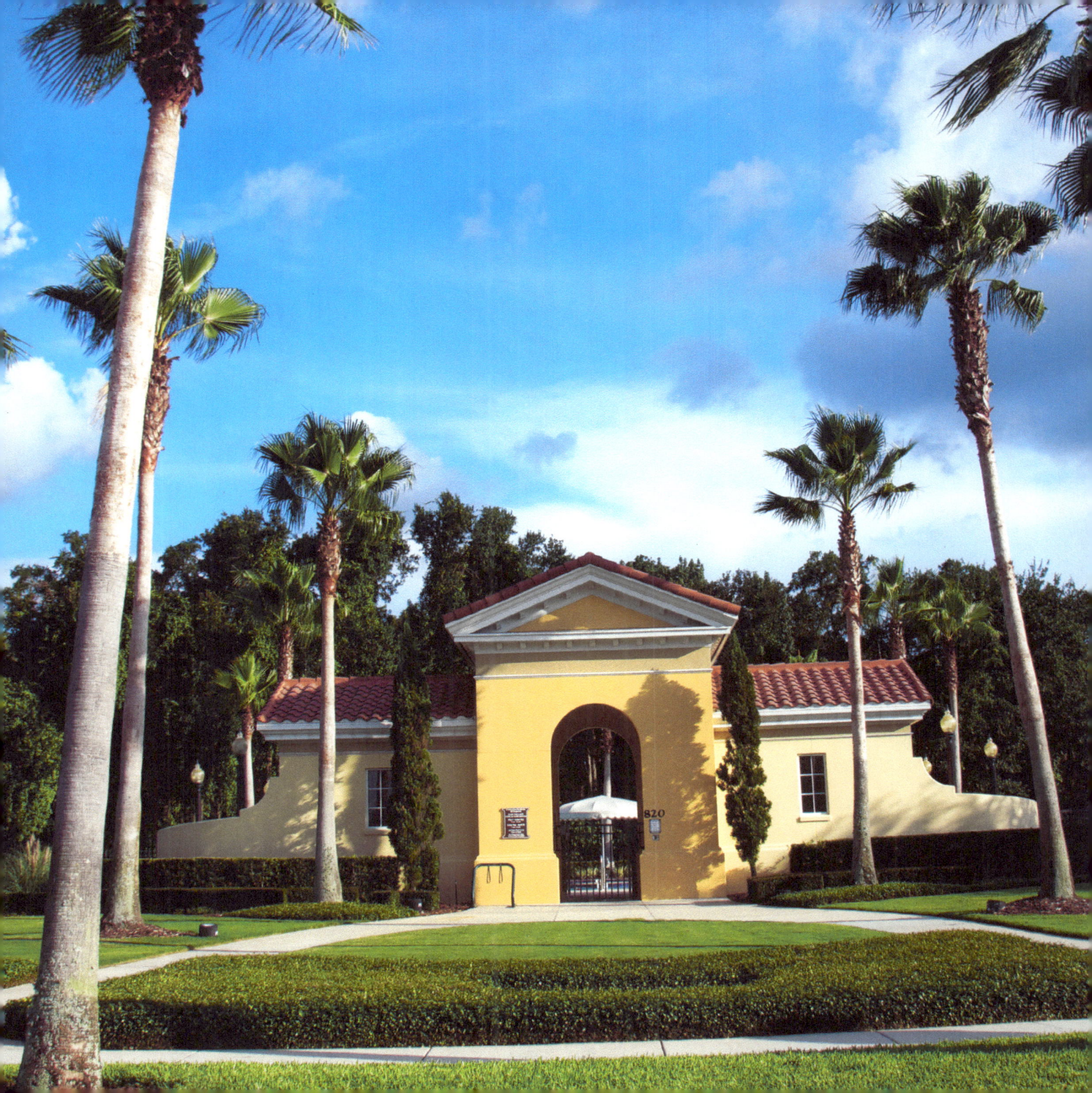

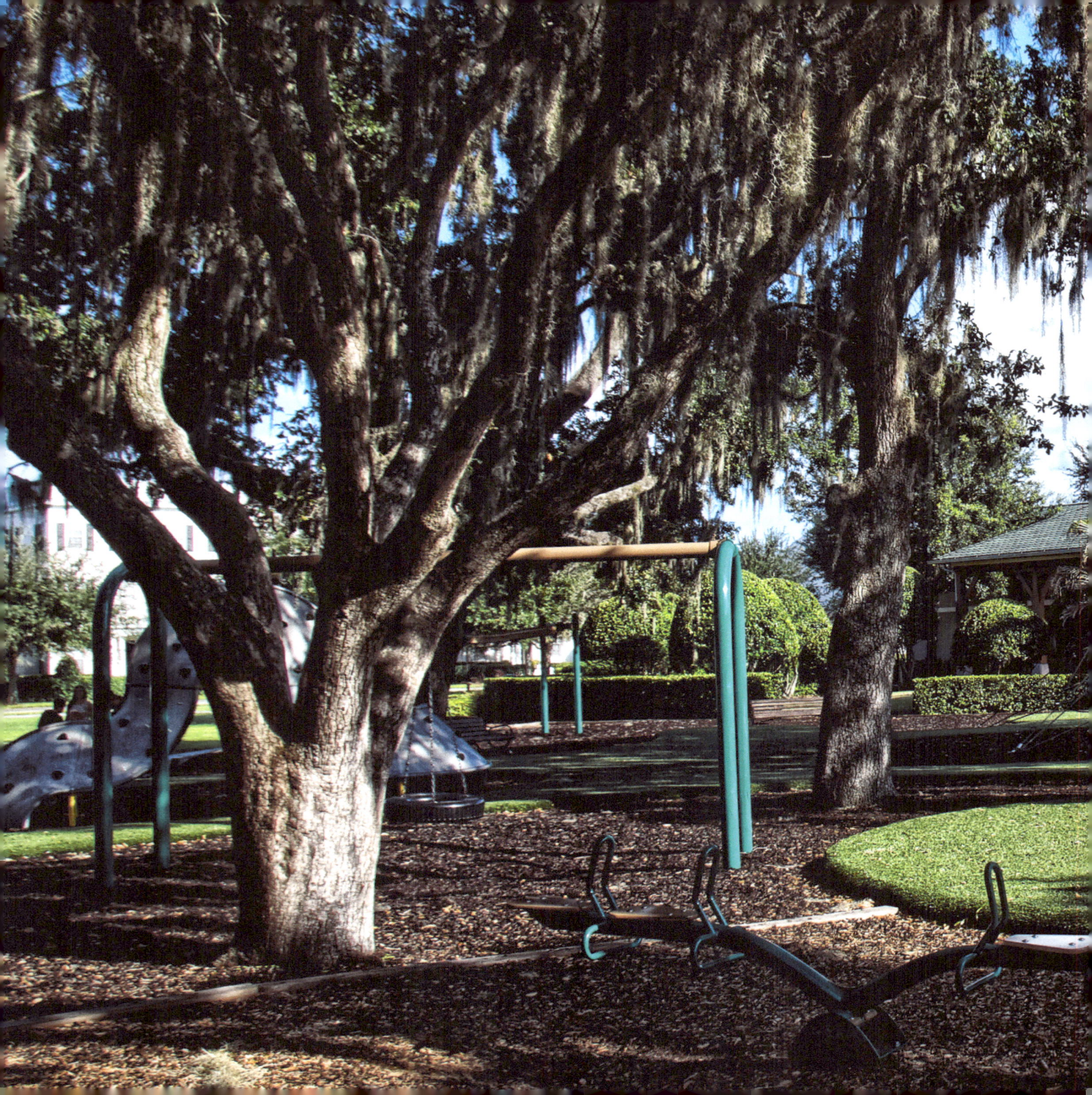

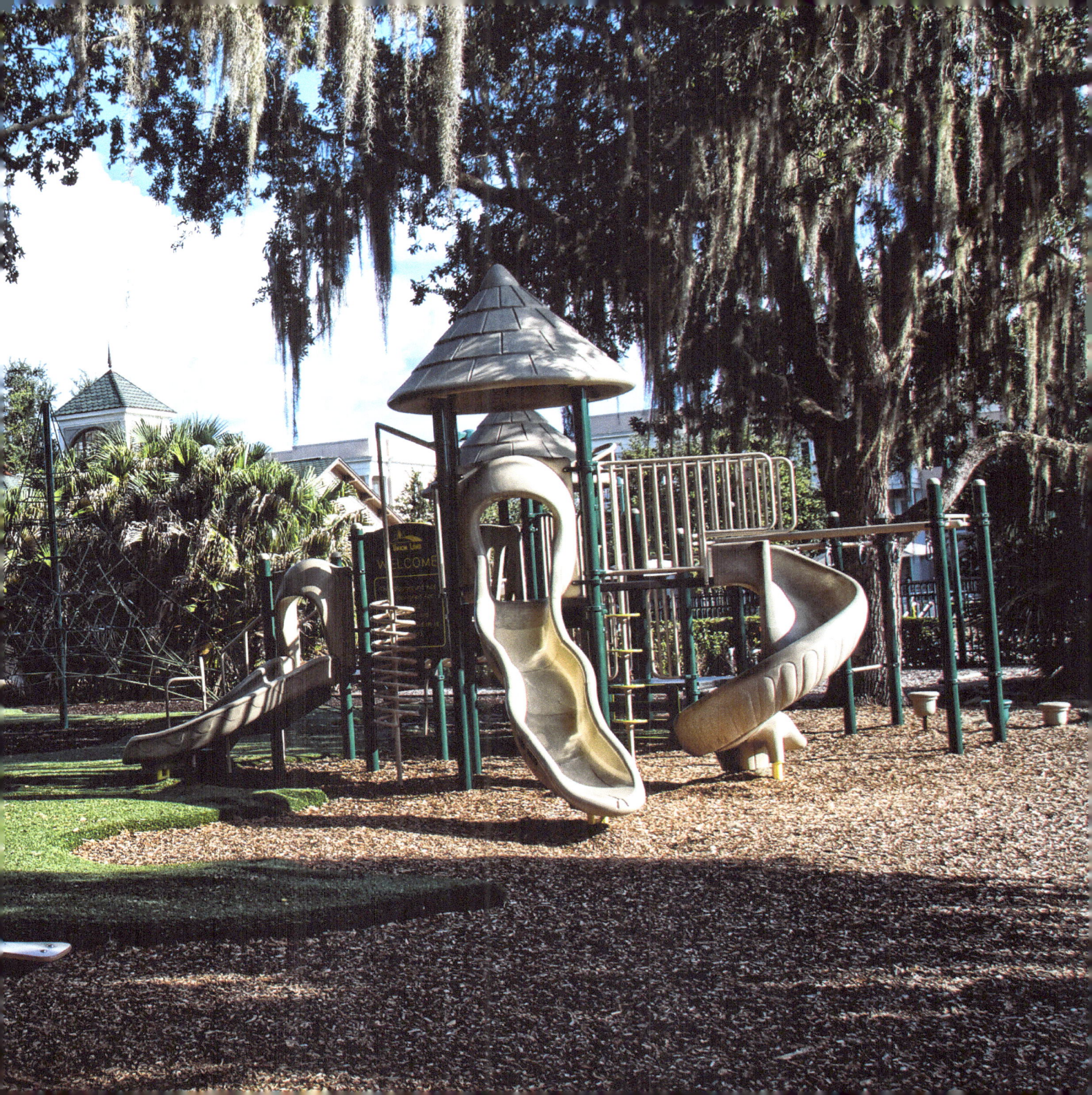

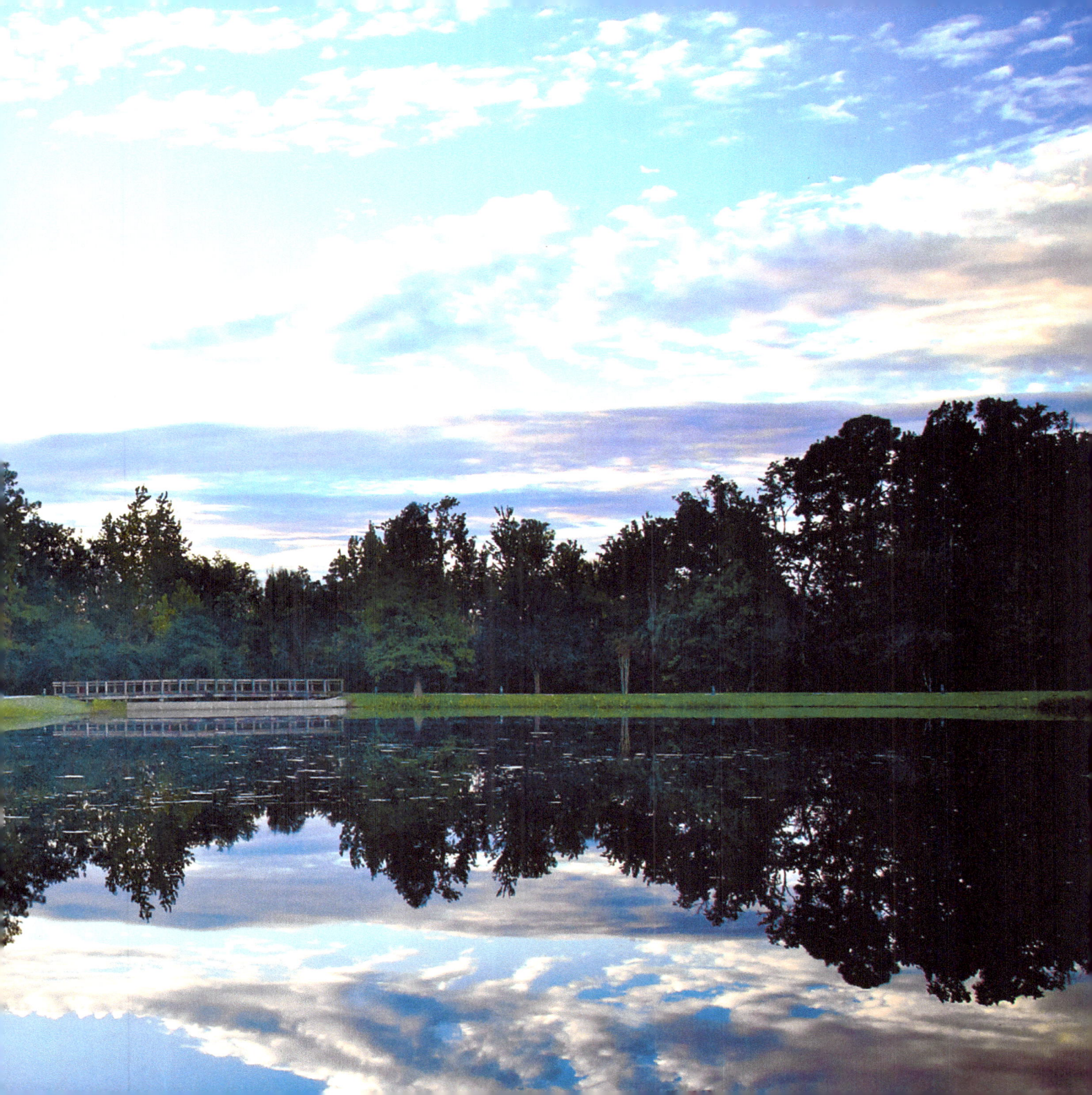

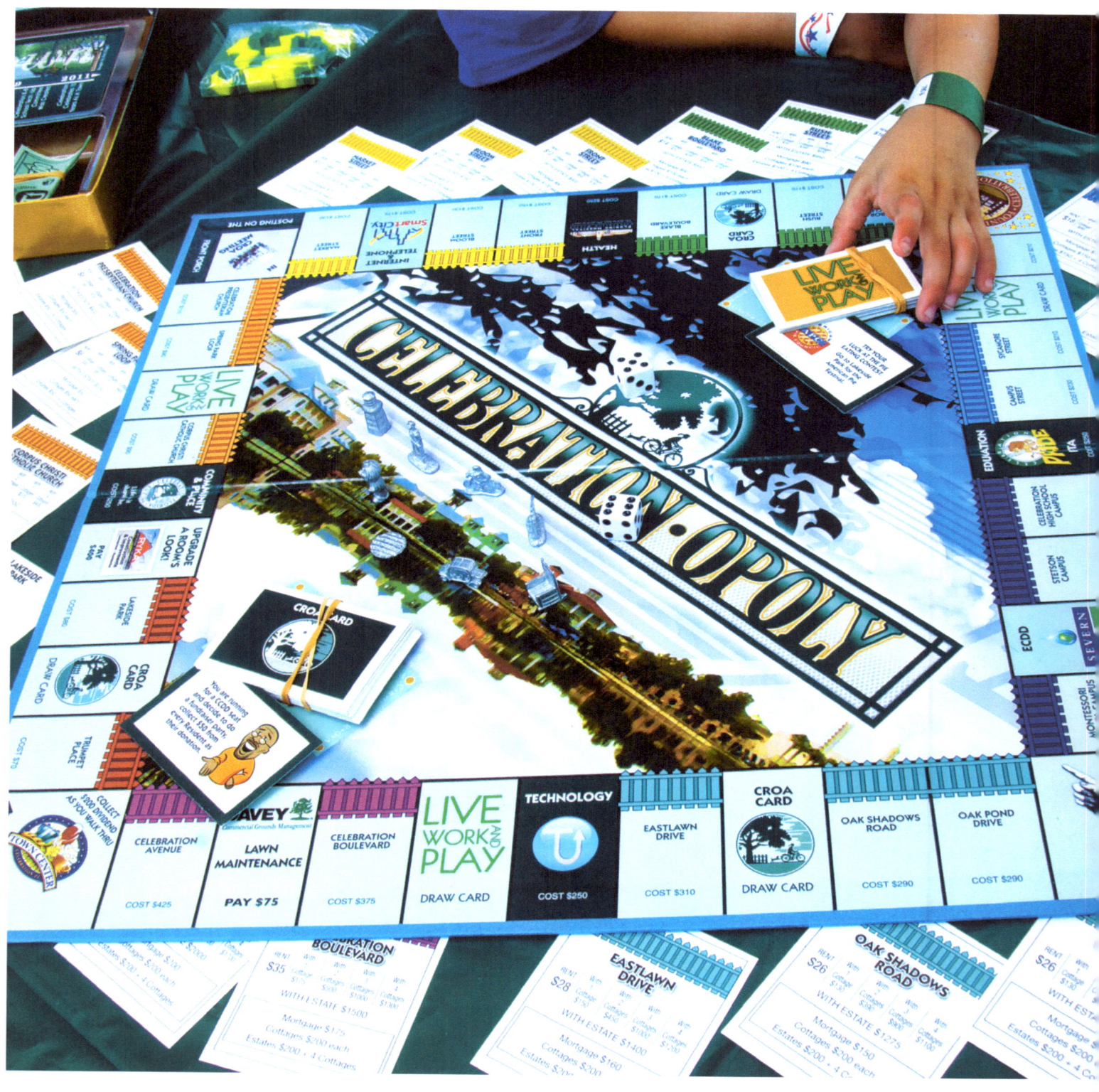

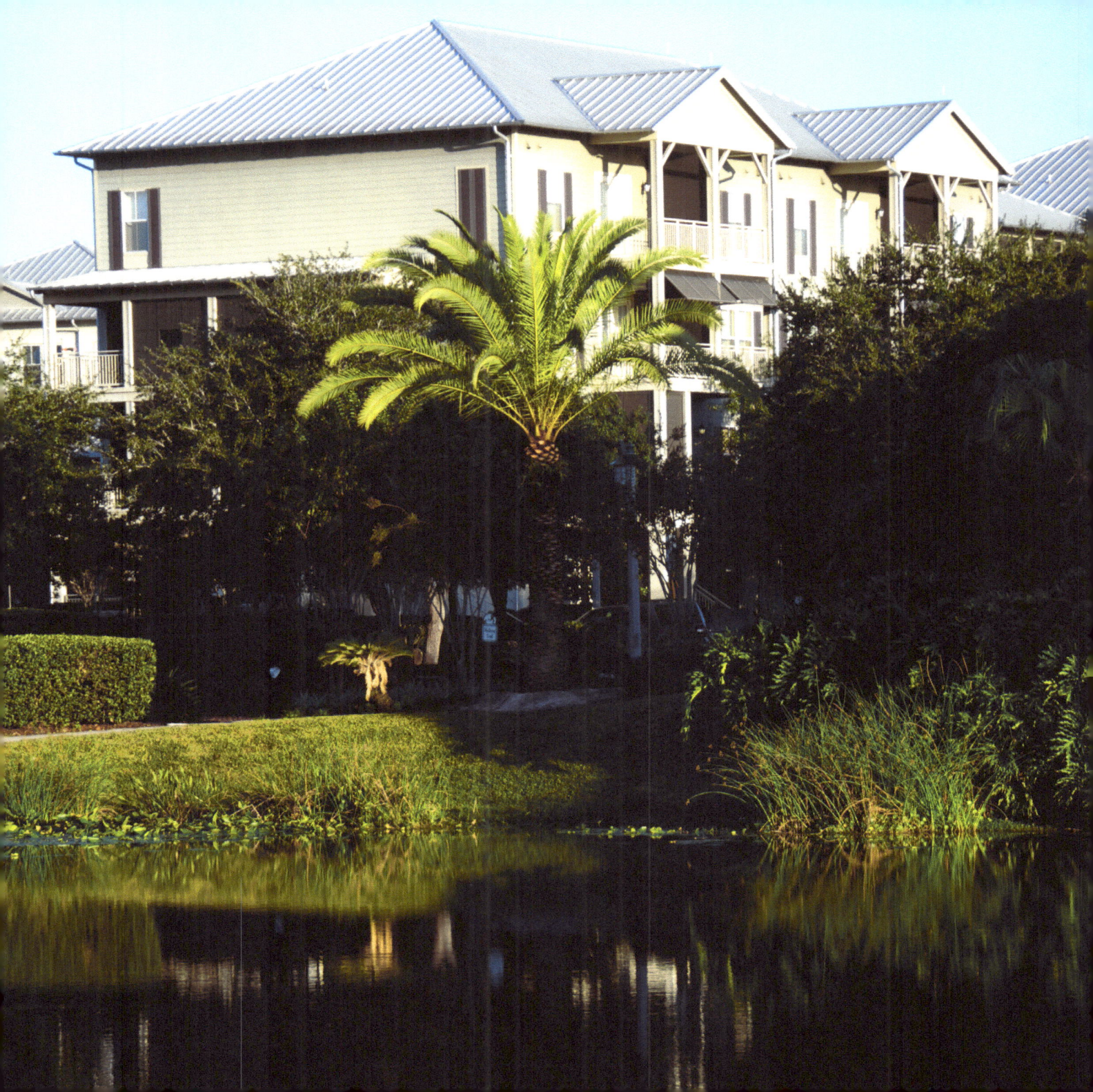

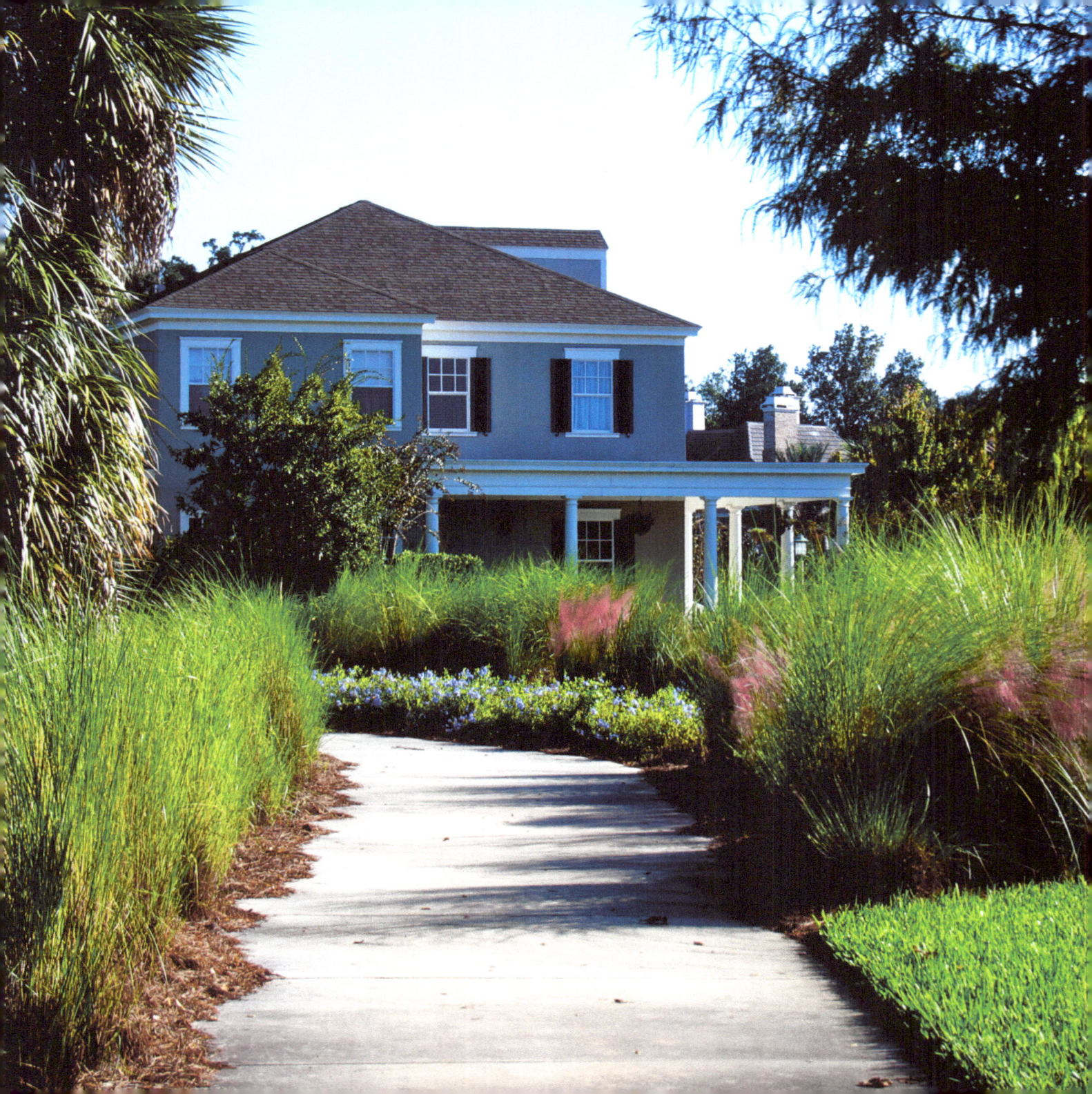

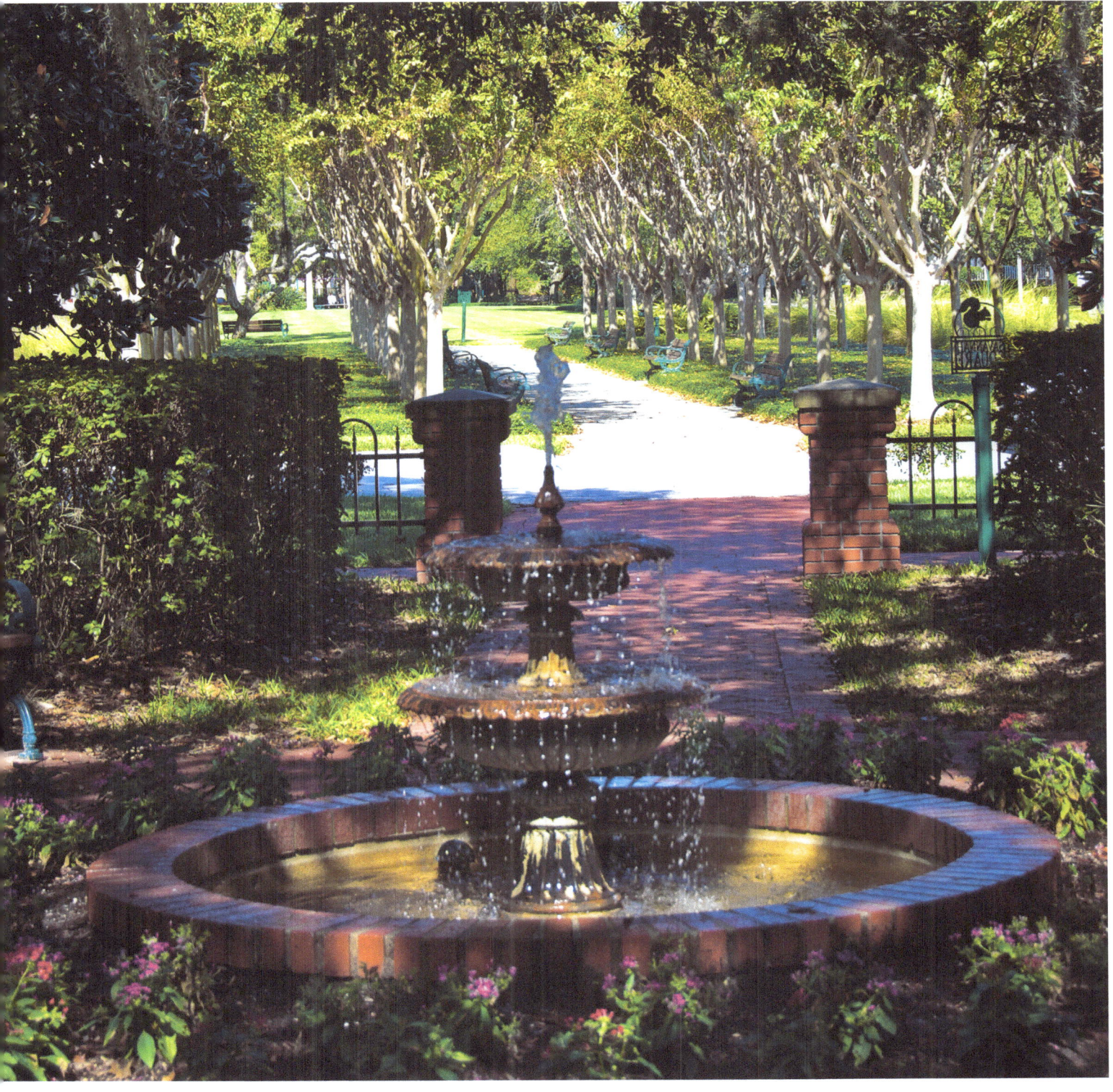

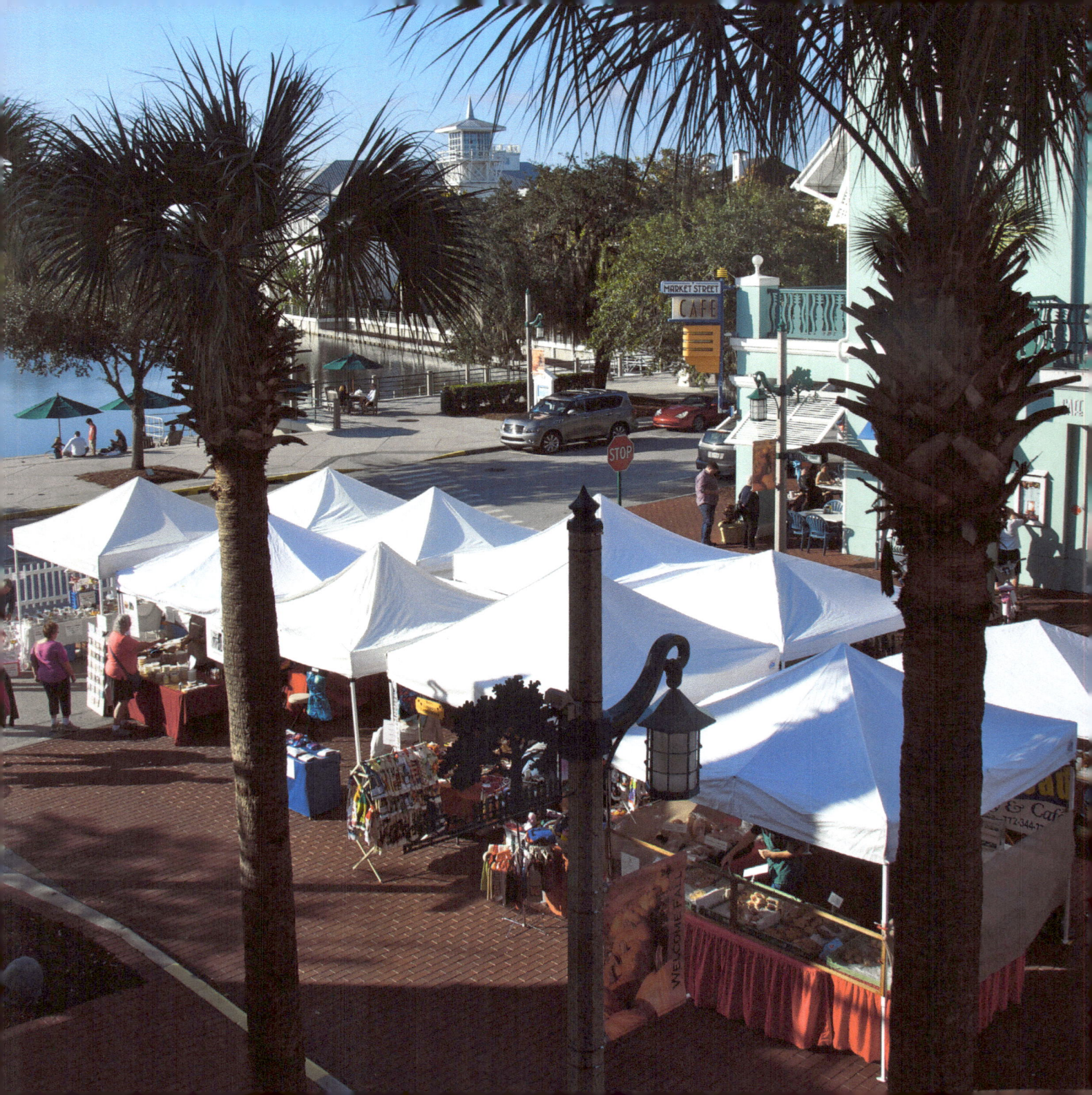

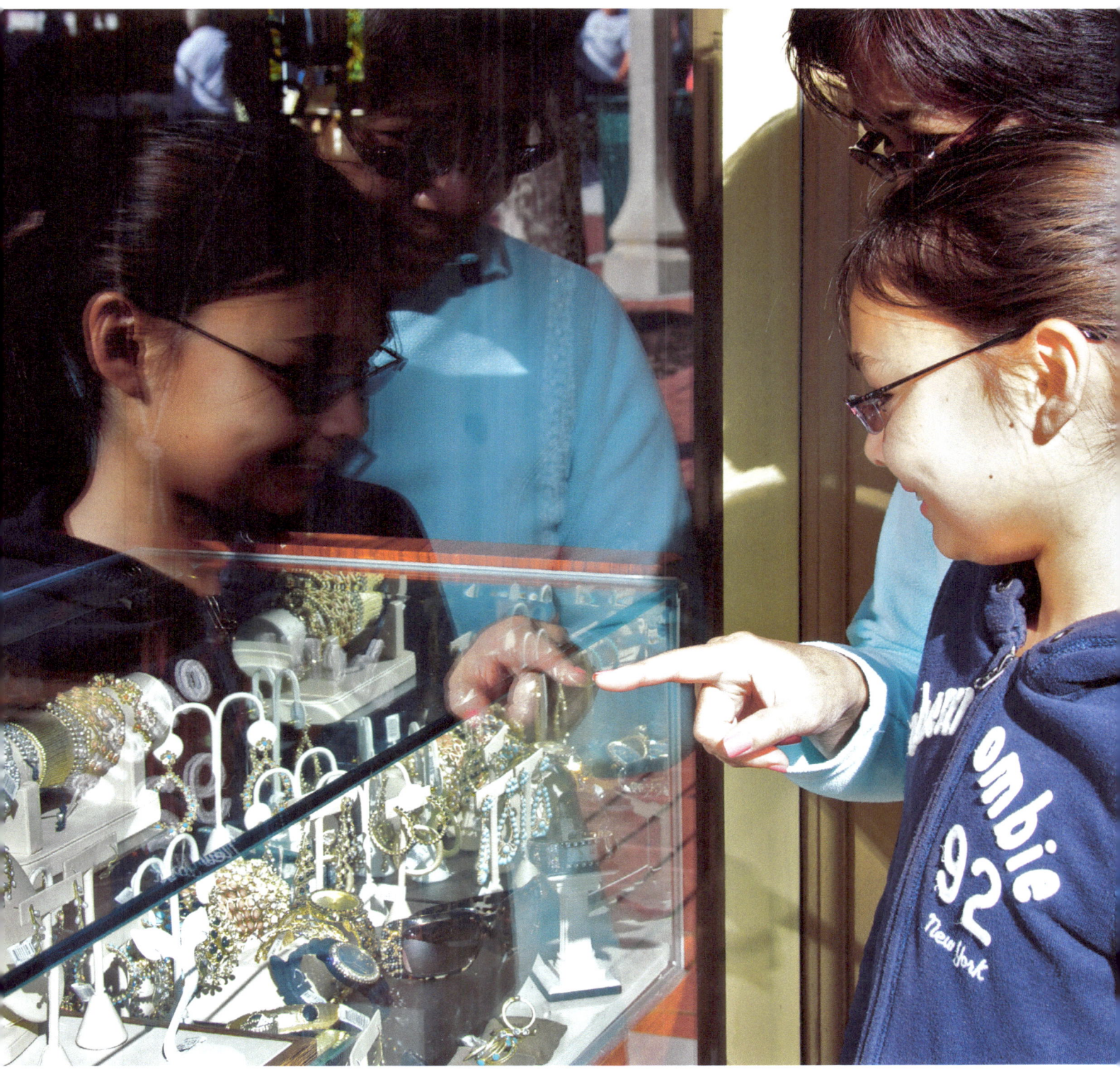

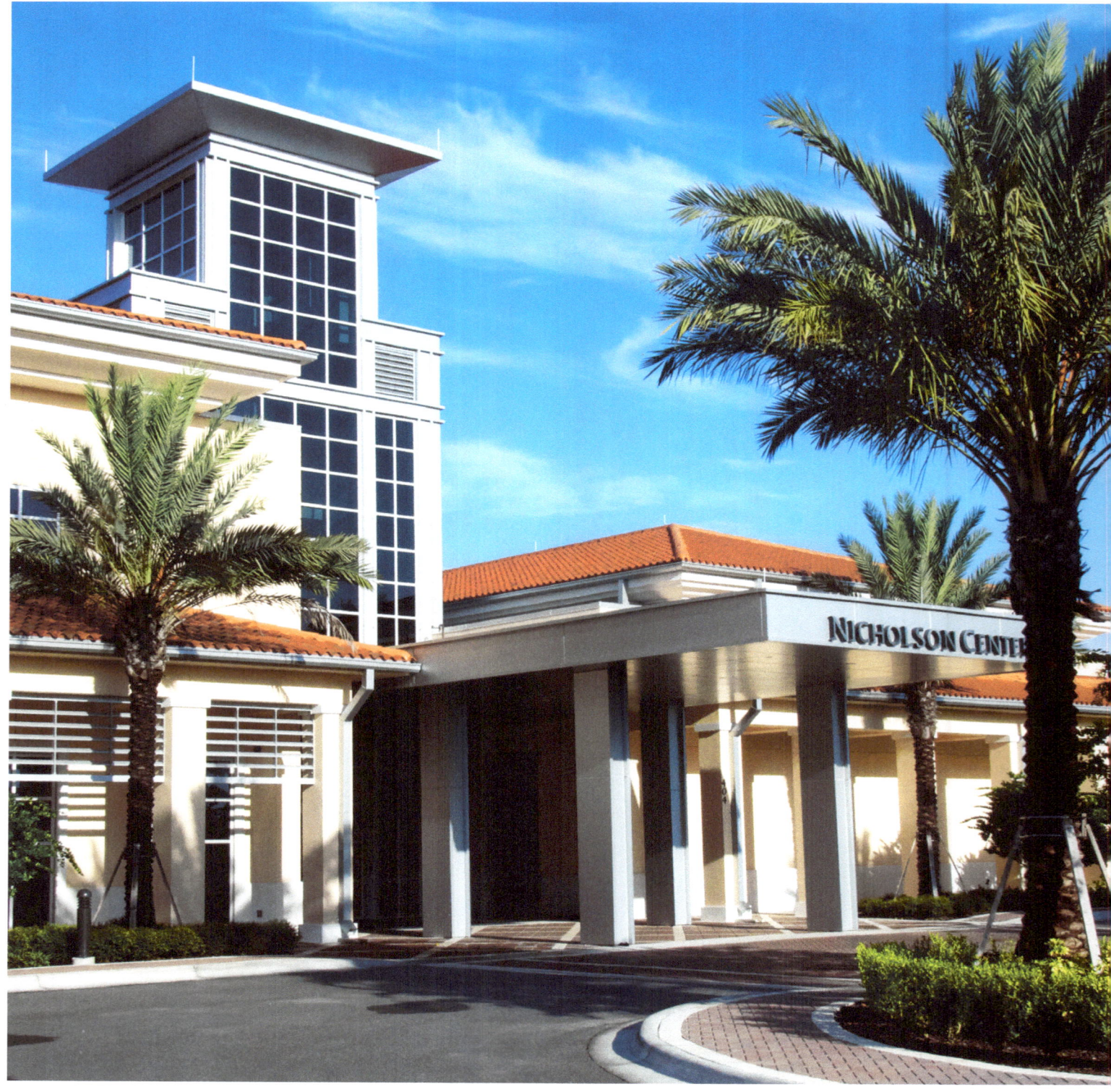

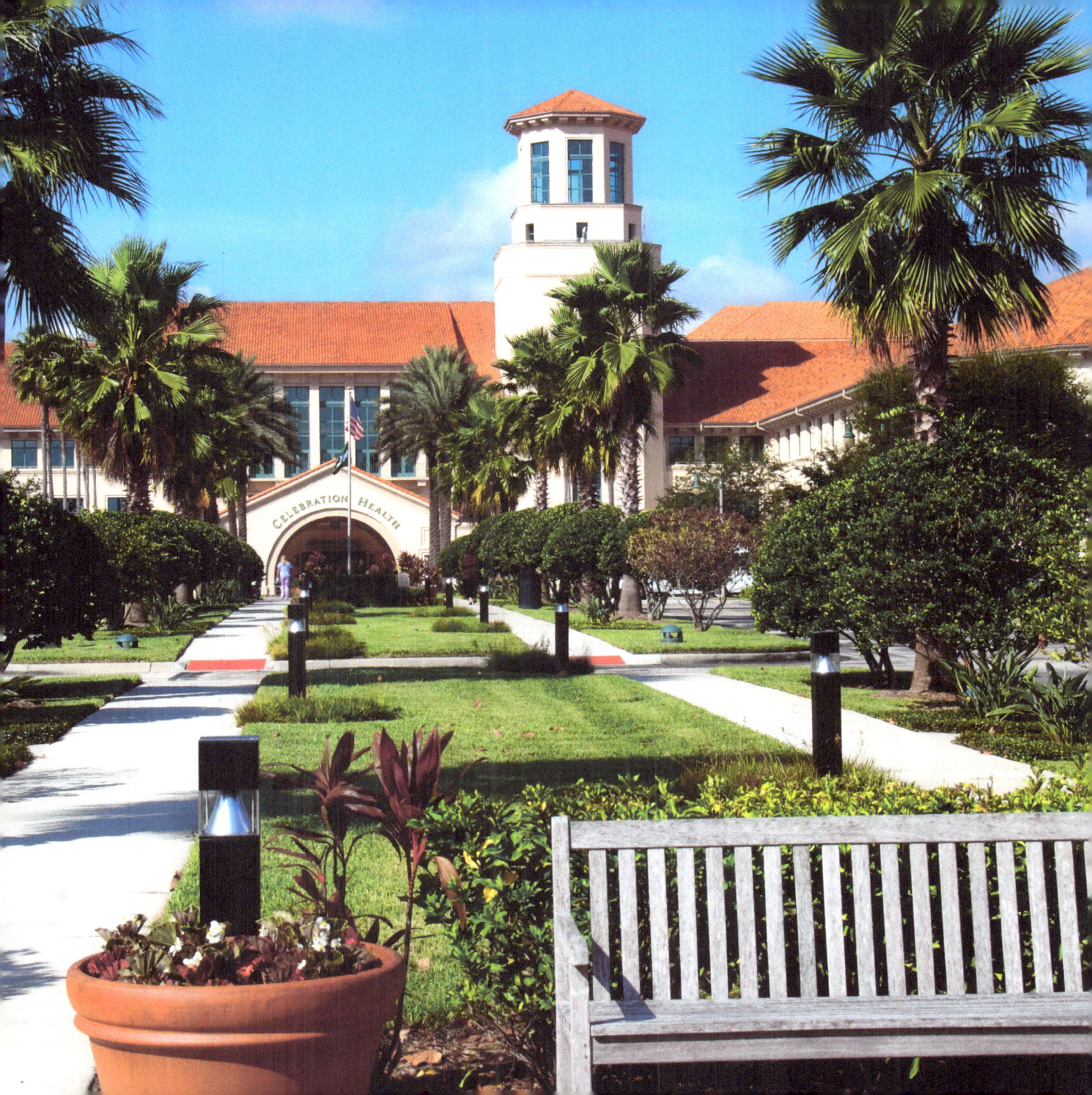

1390

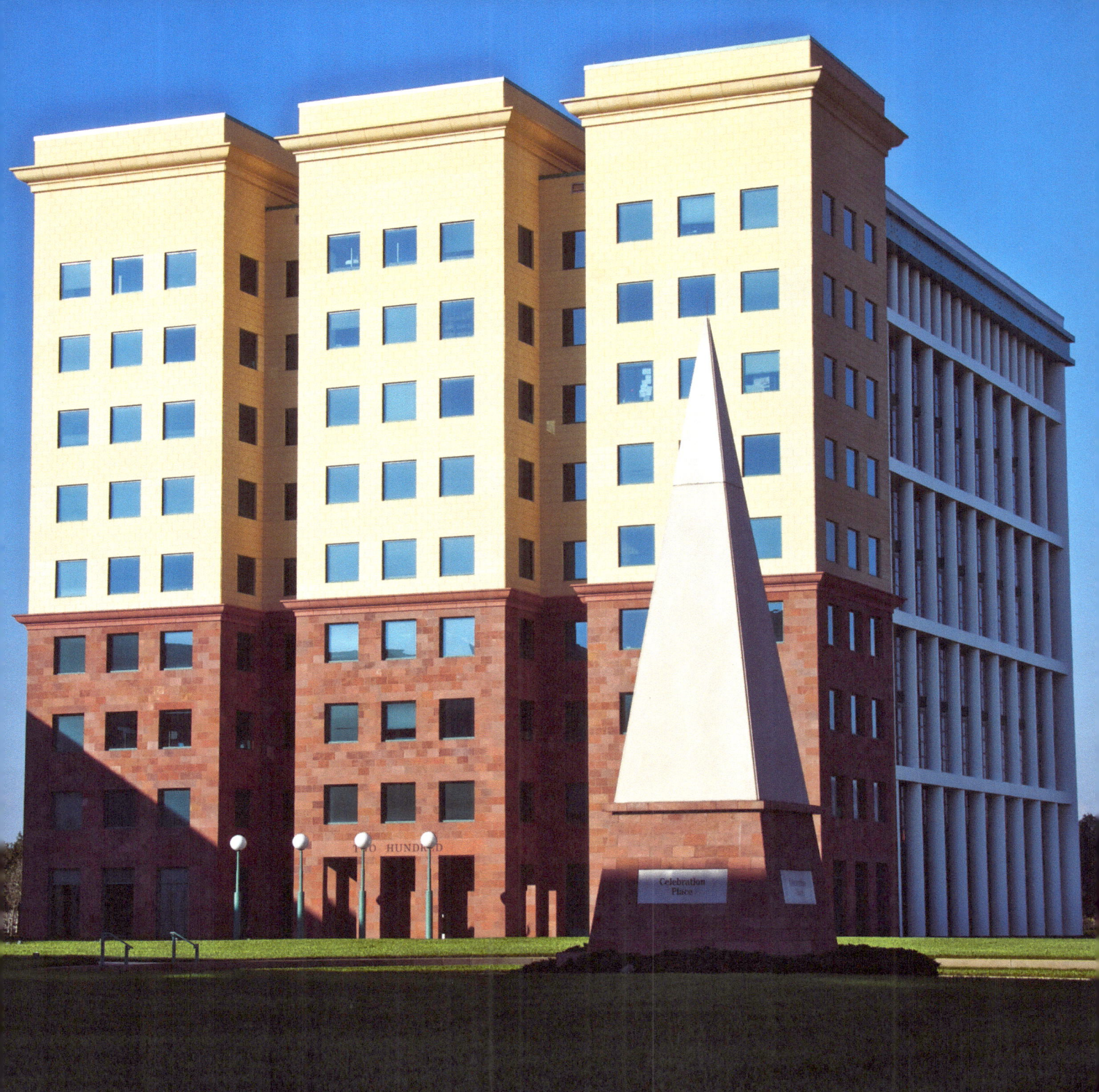

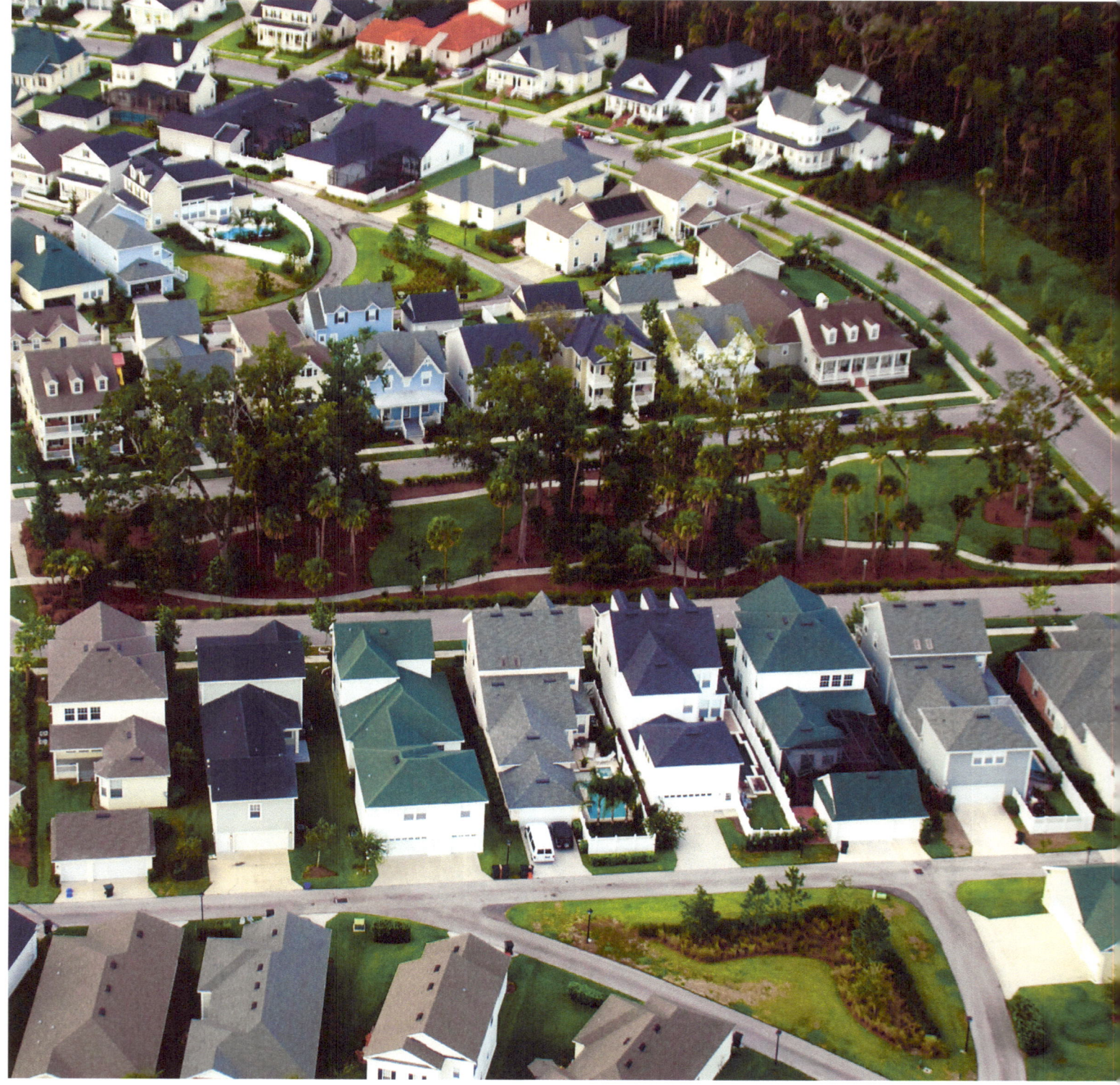

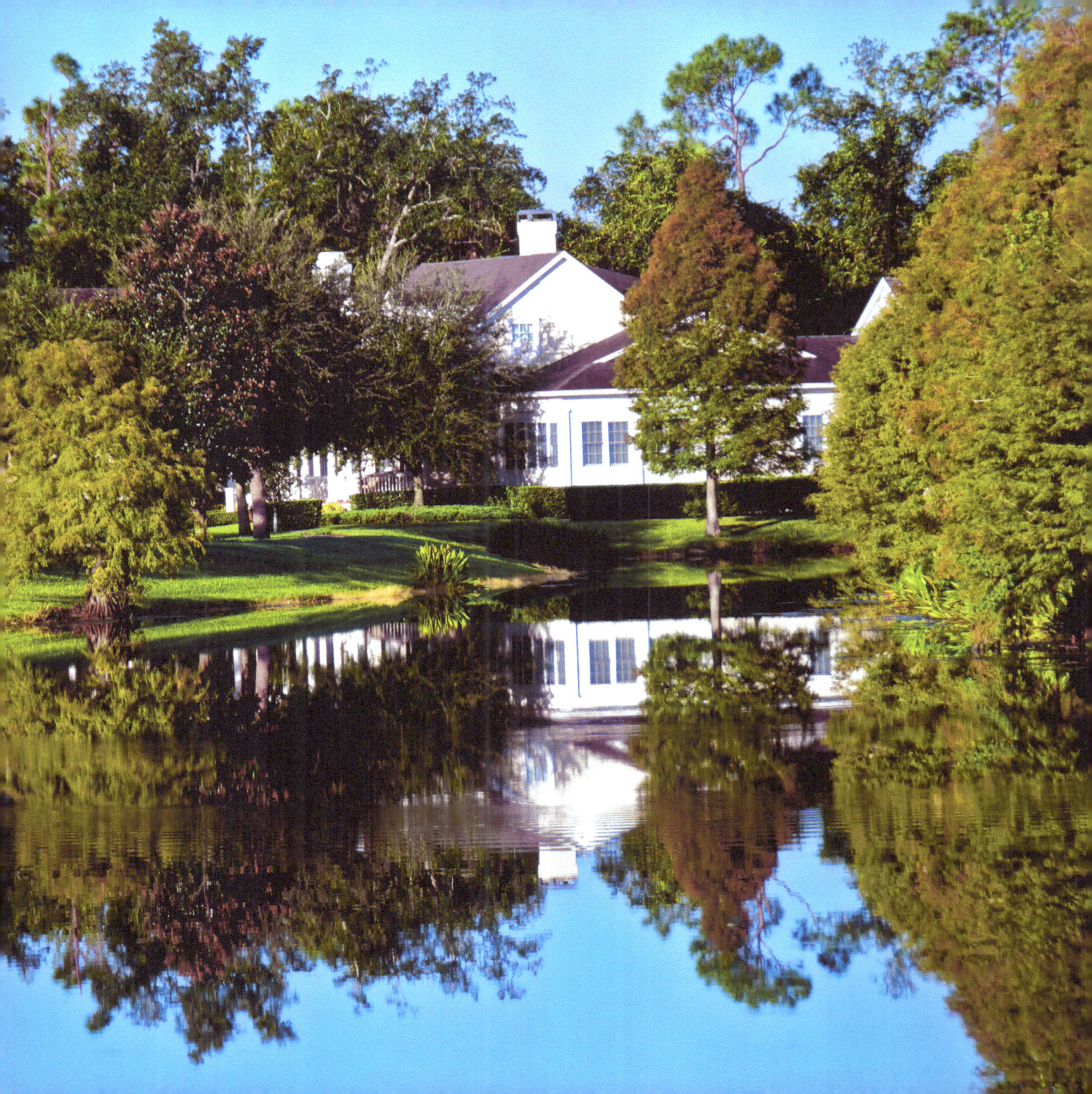

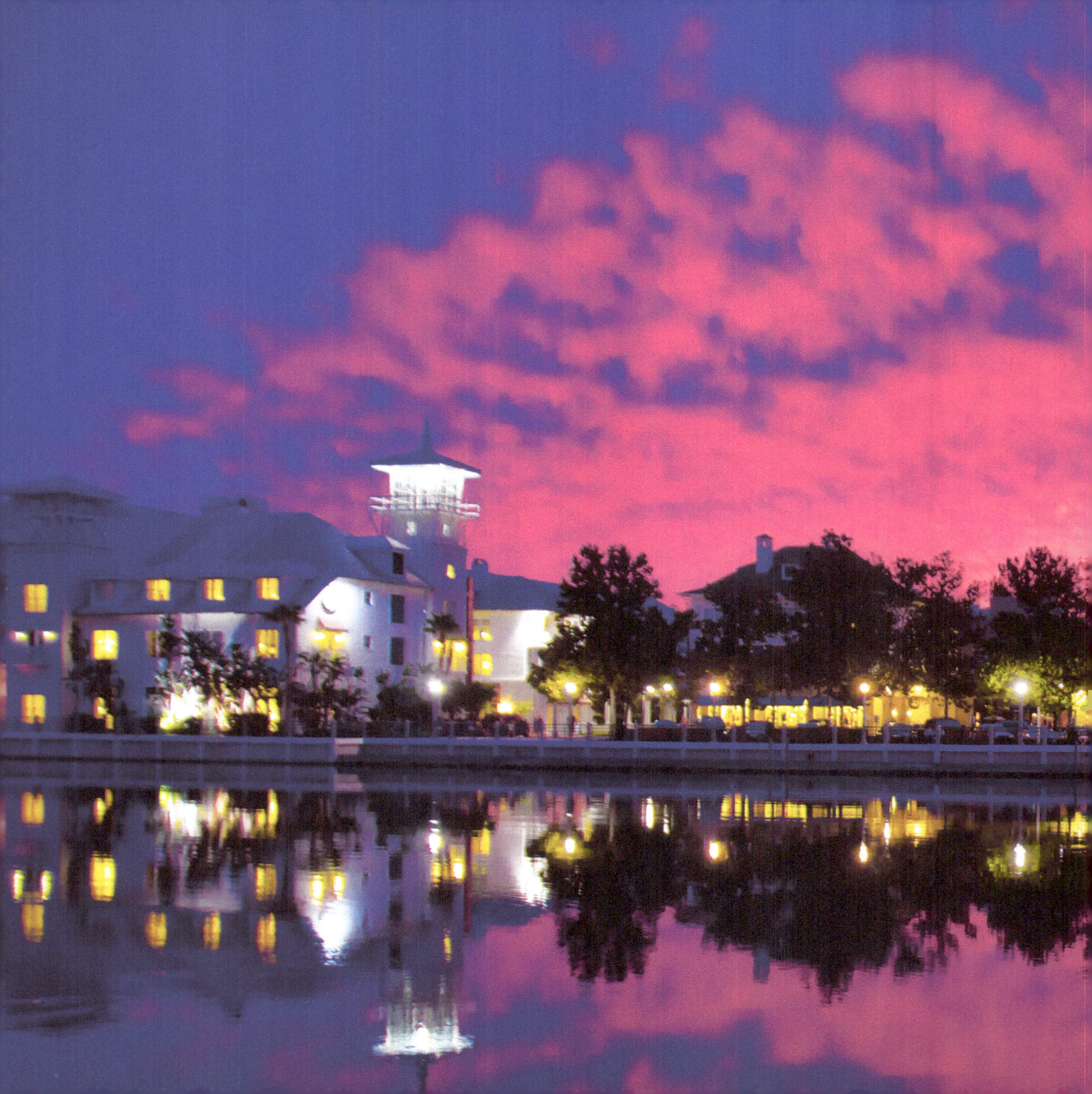

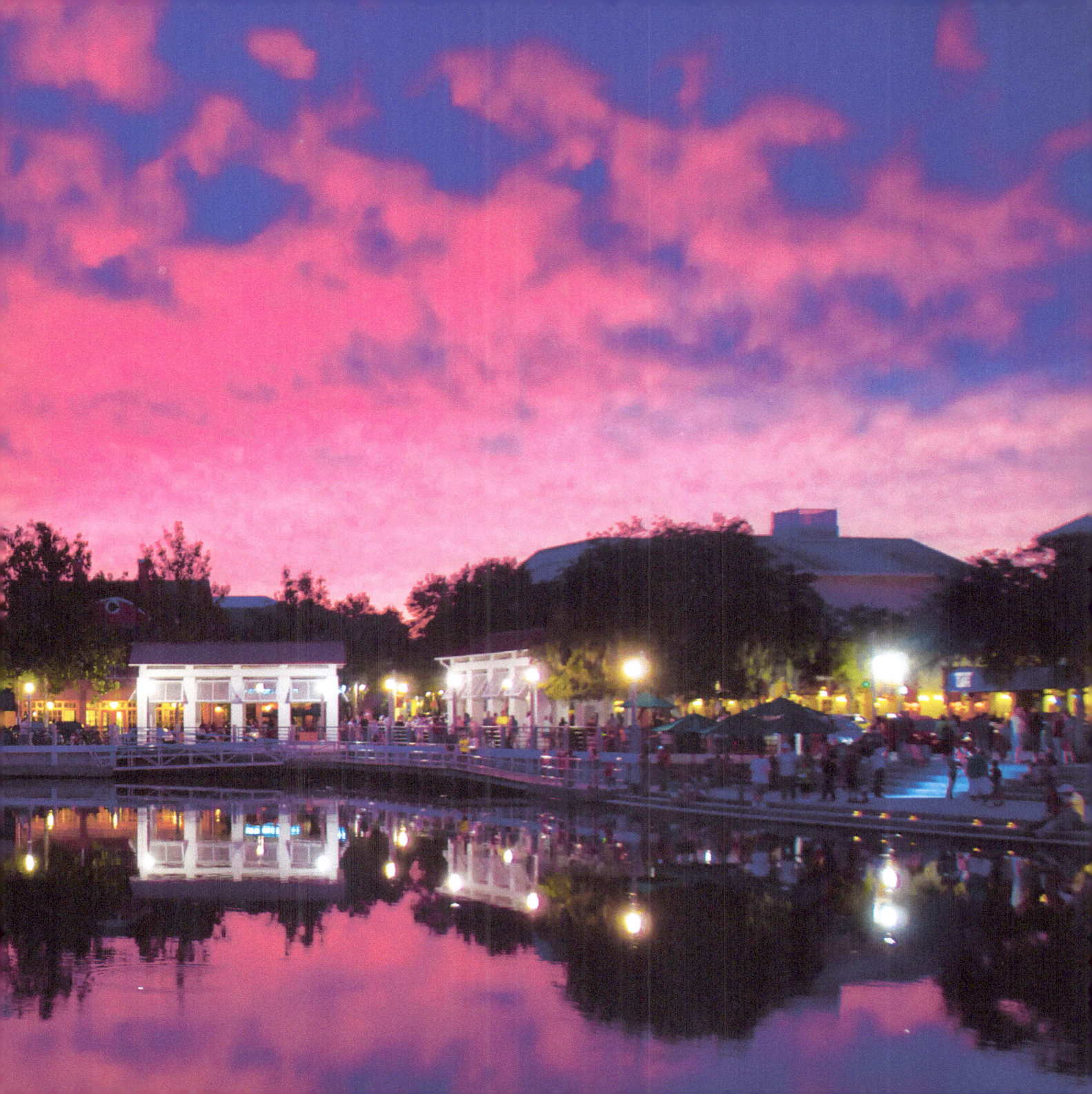

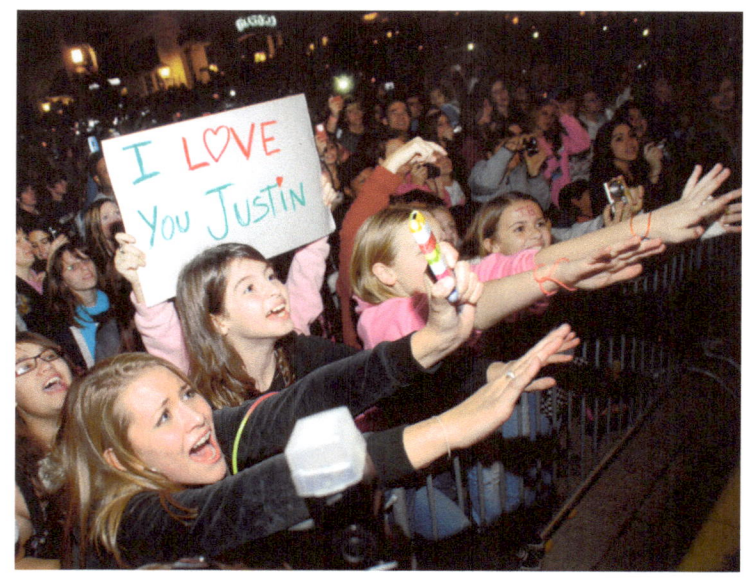

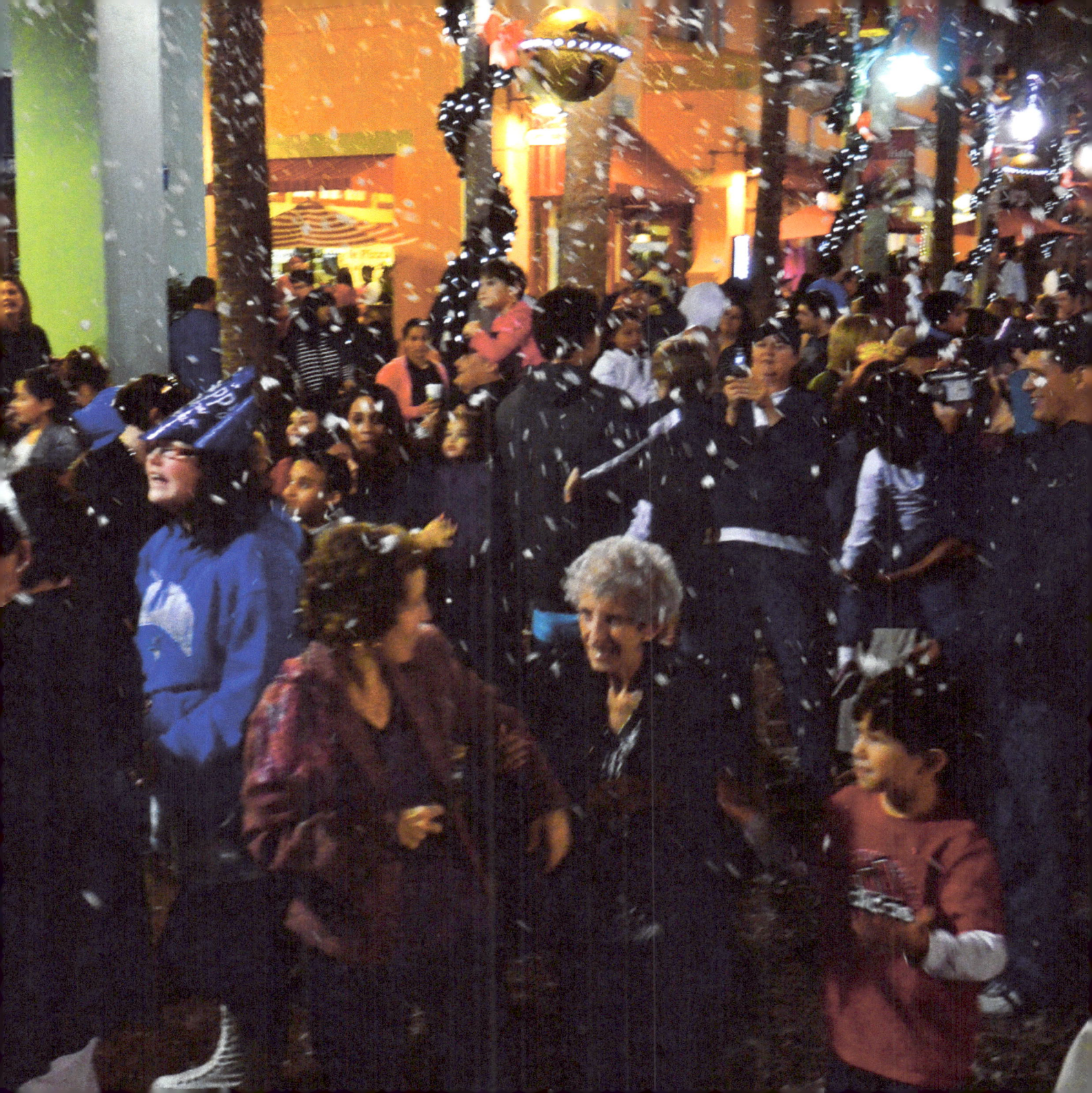

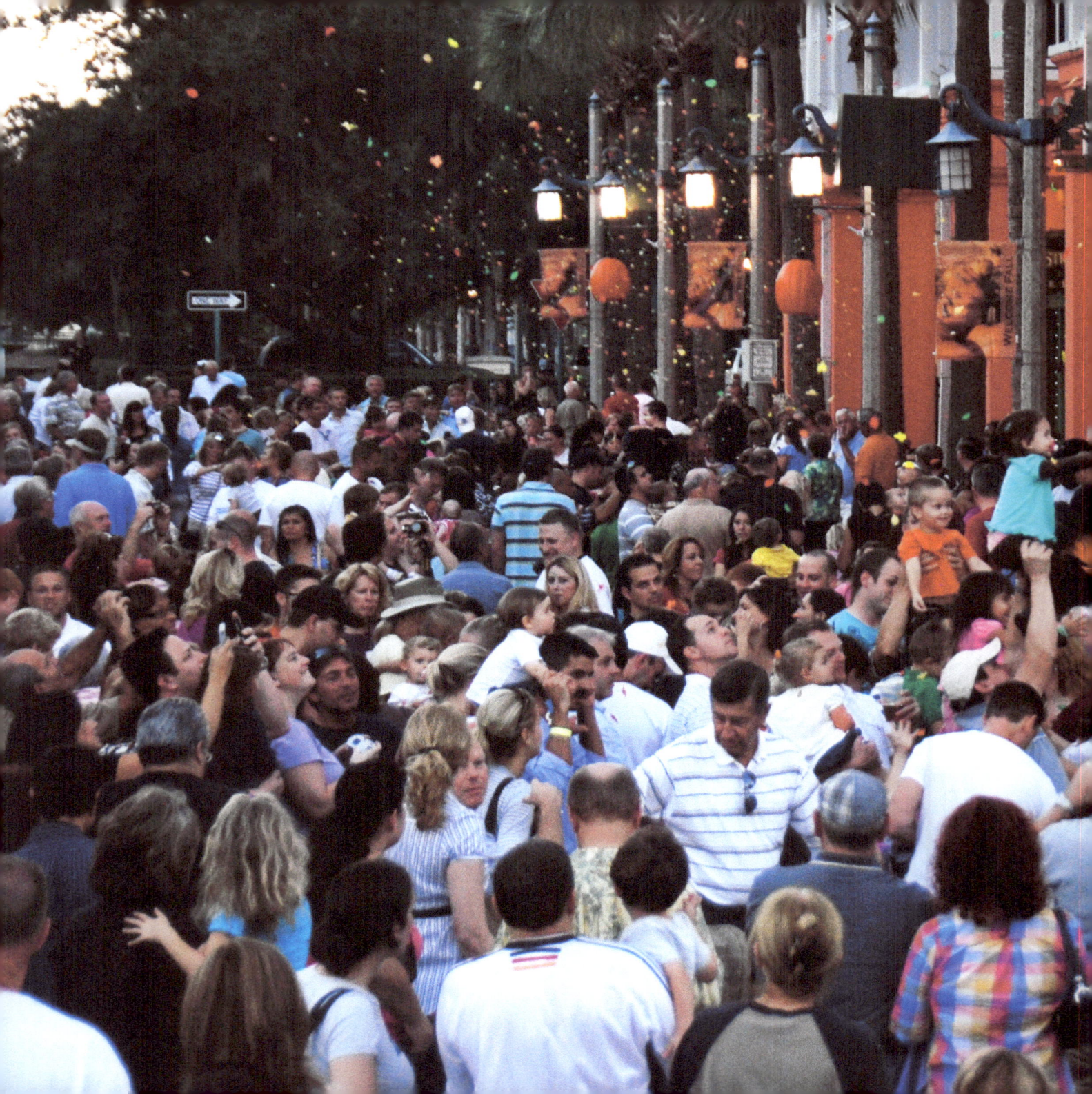

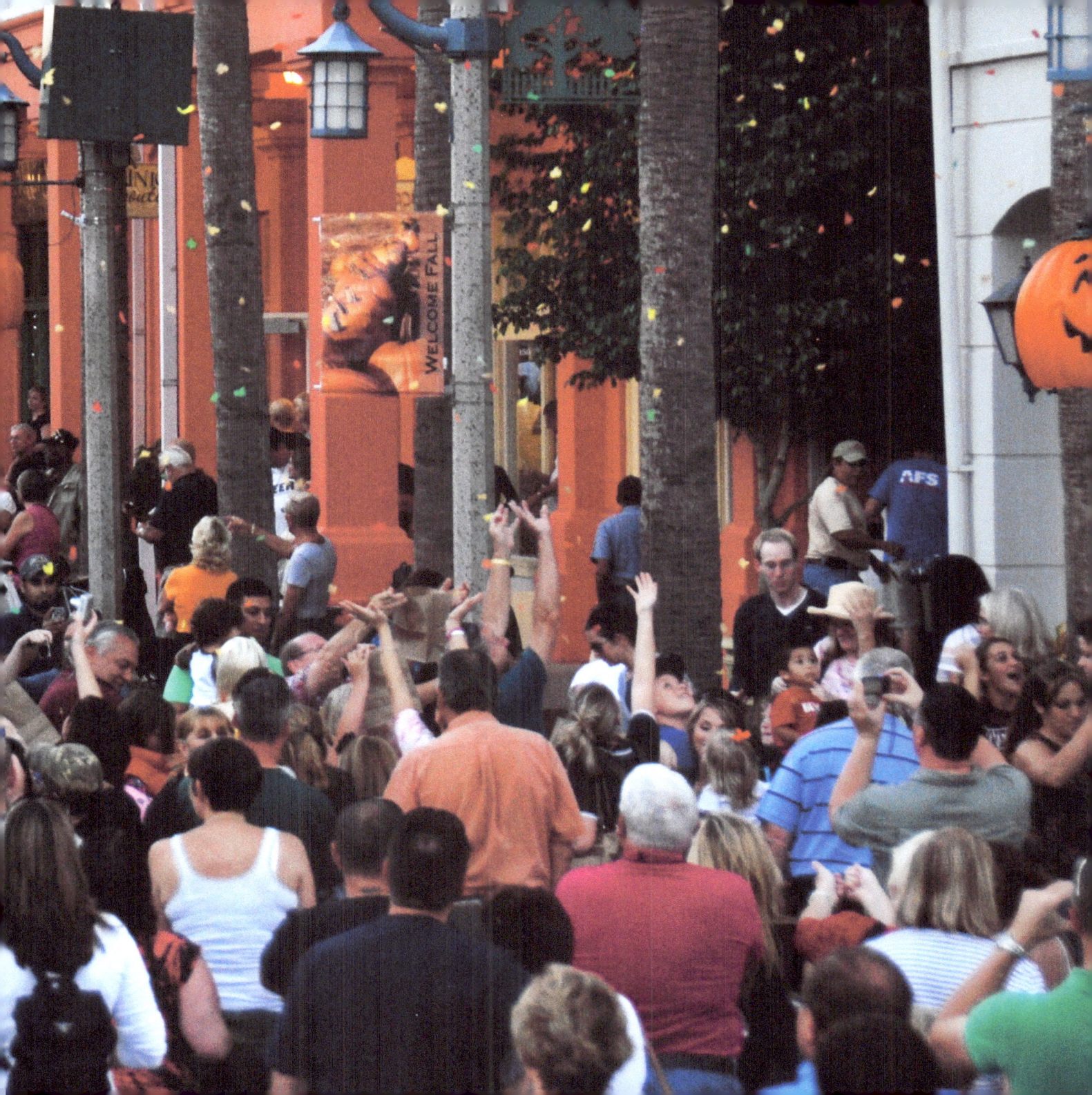

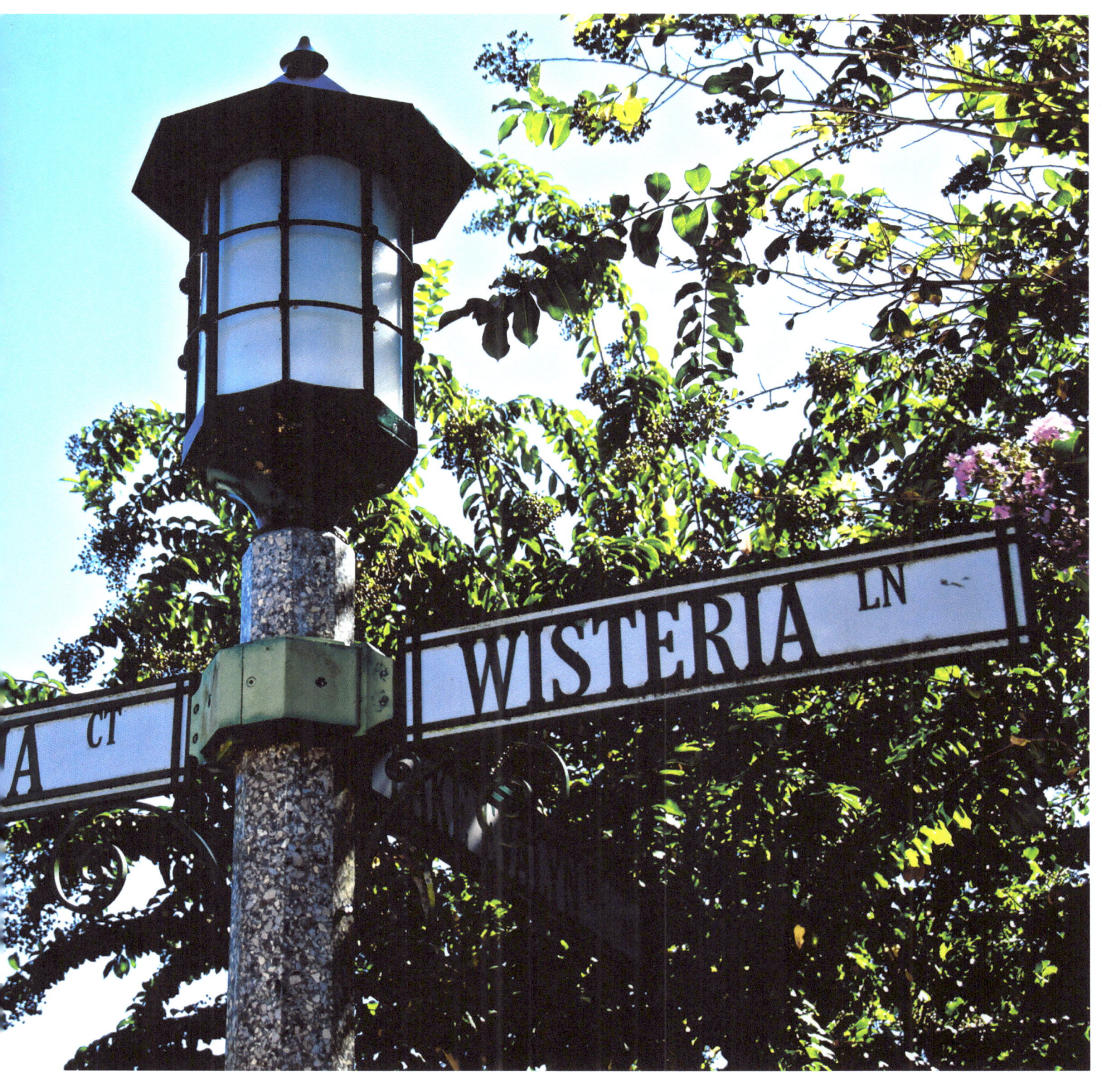

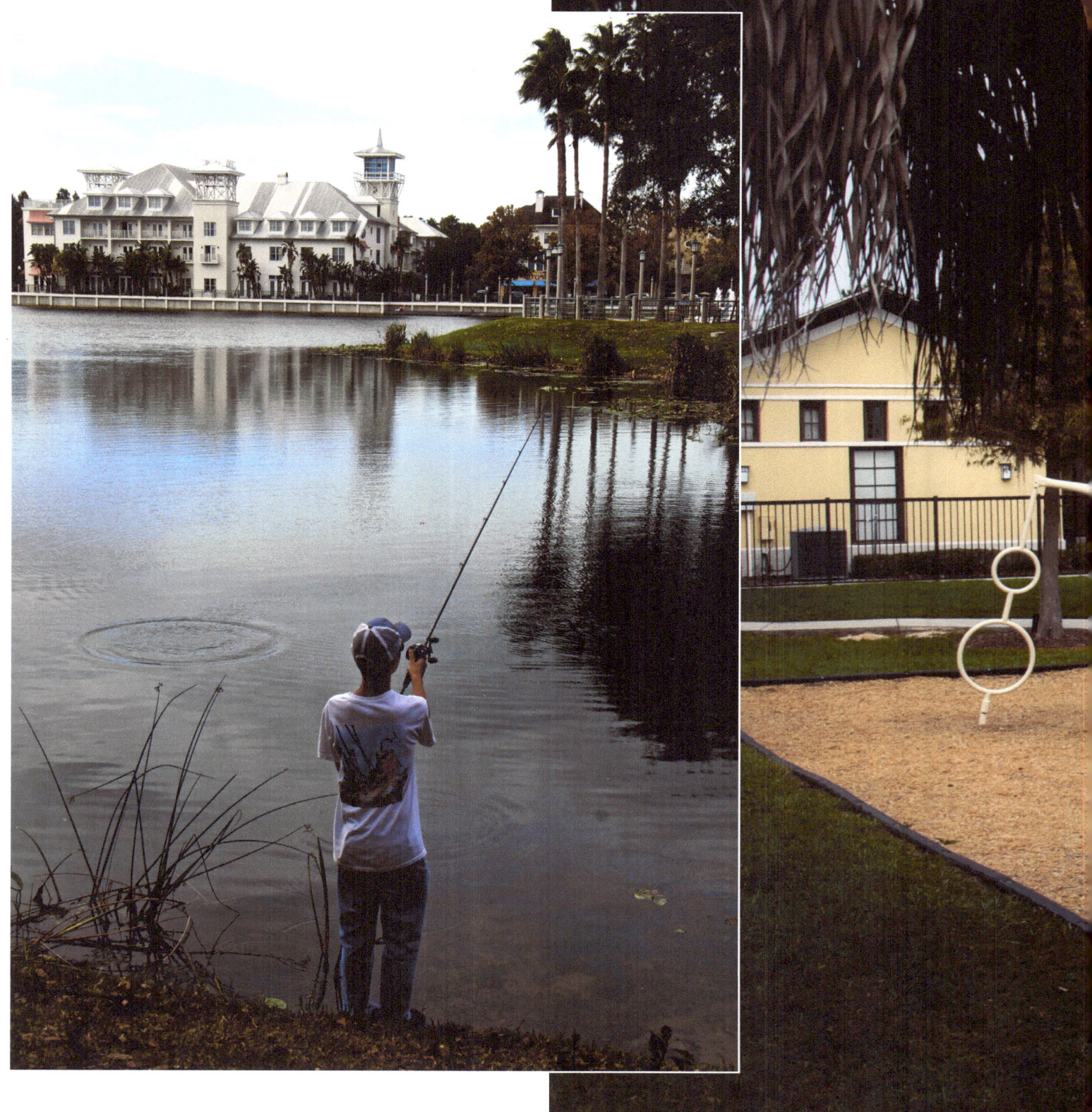

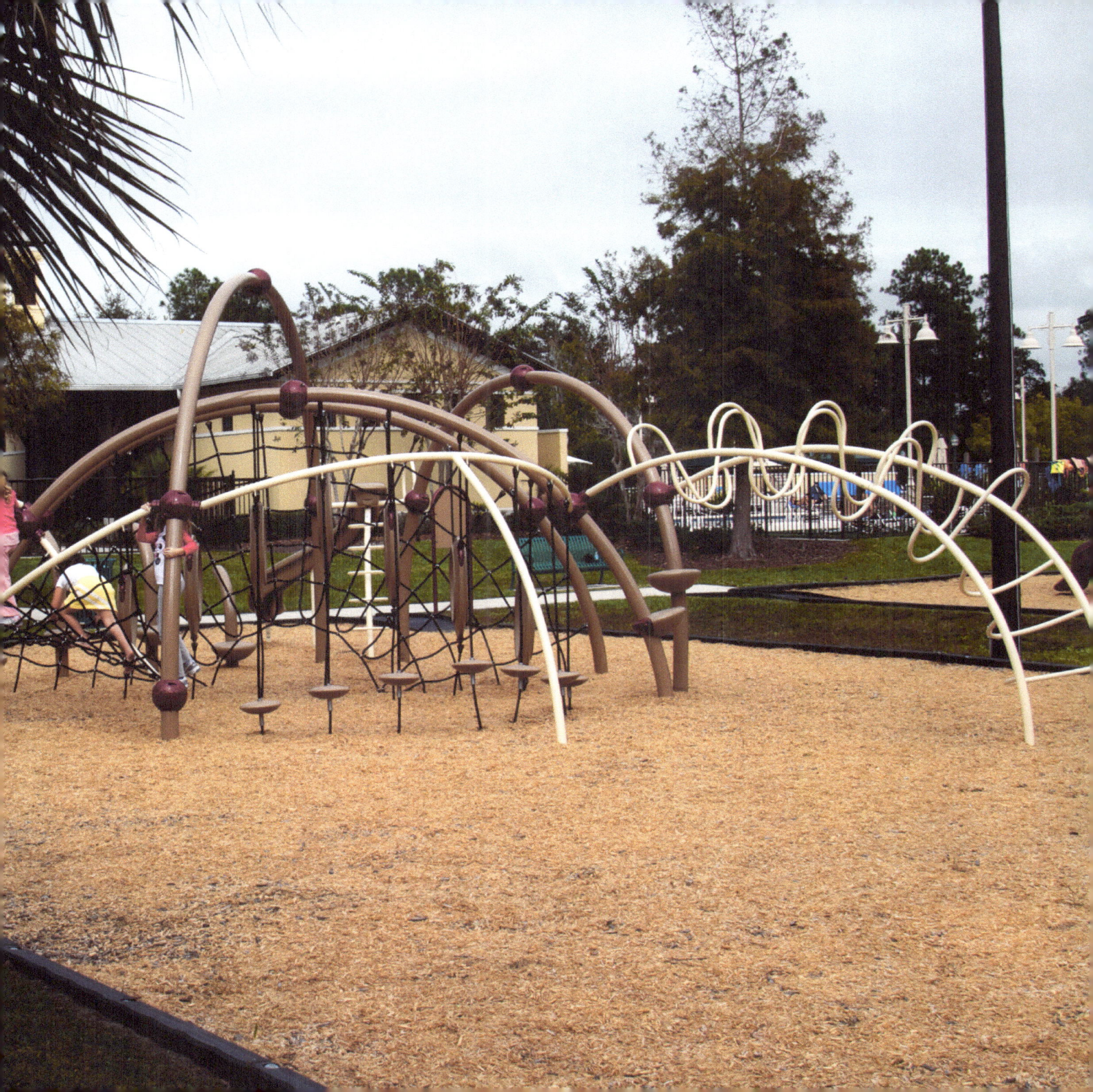

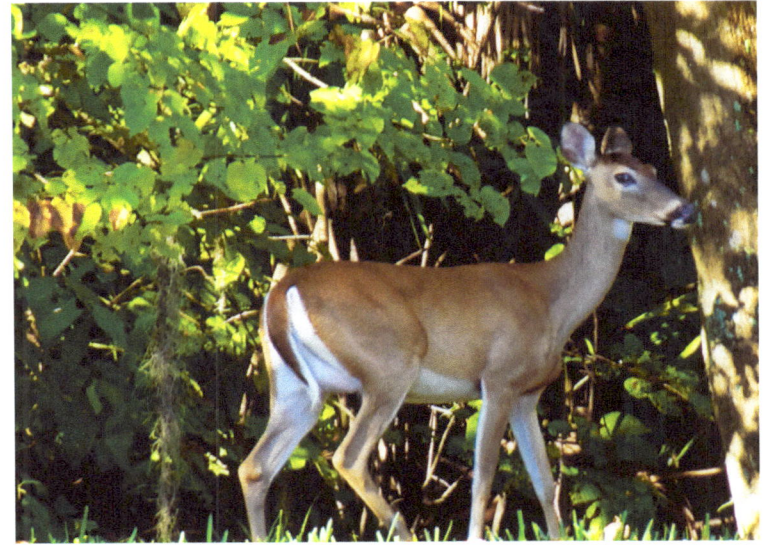

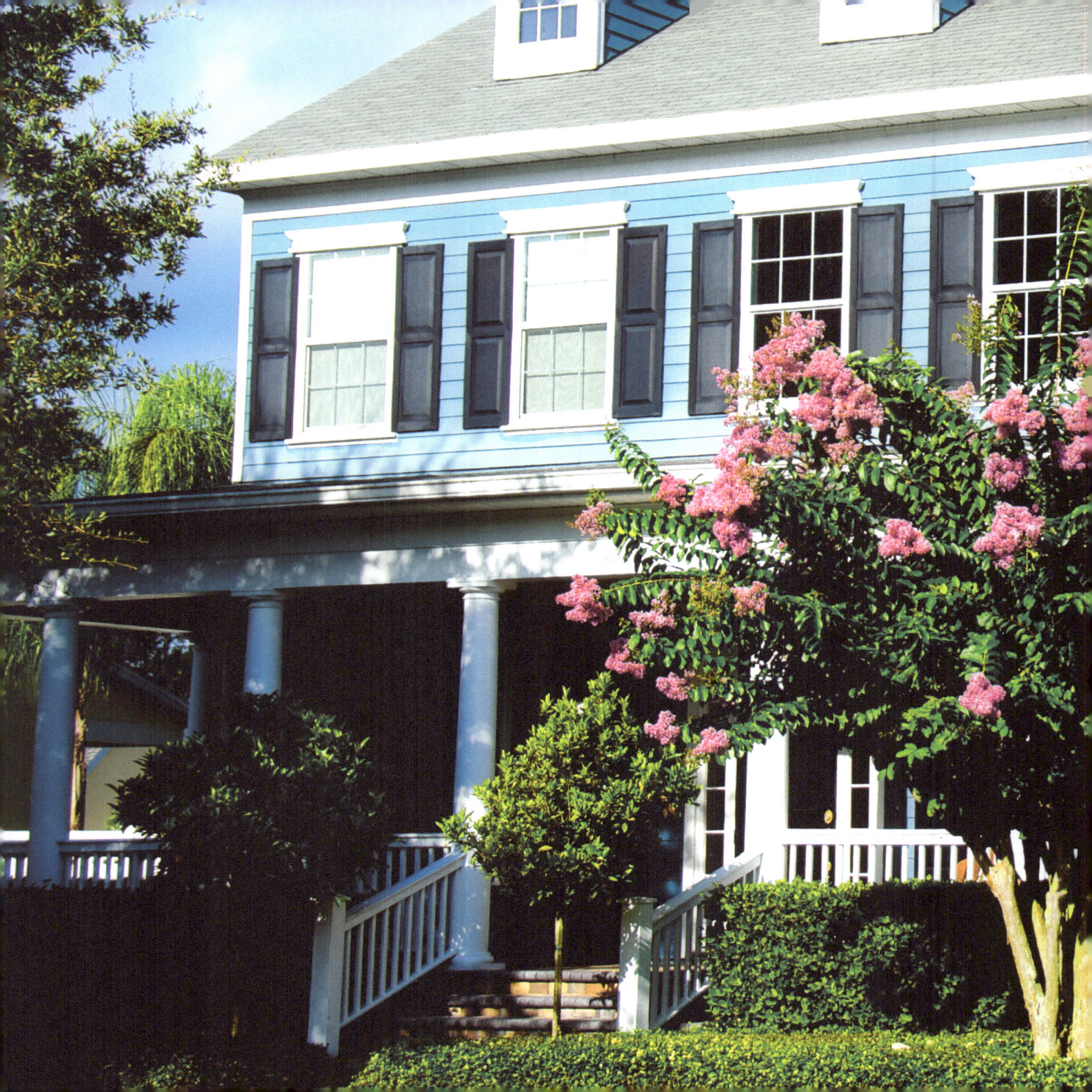

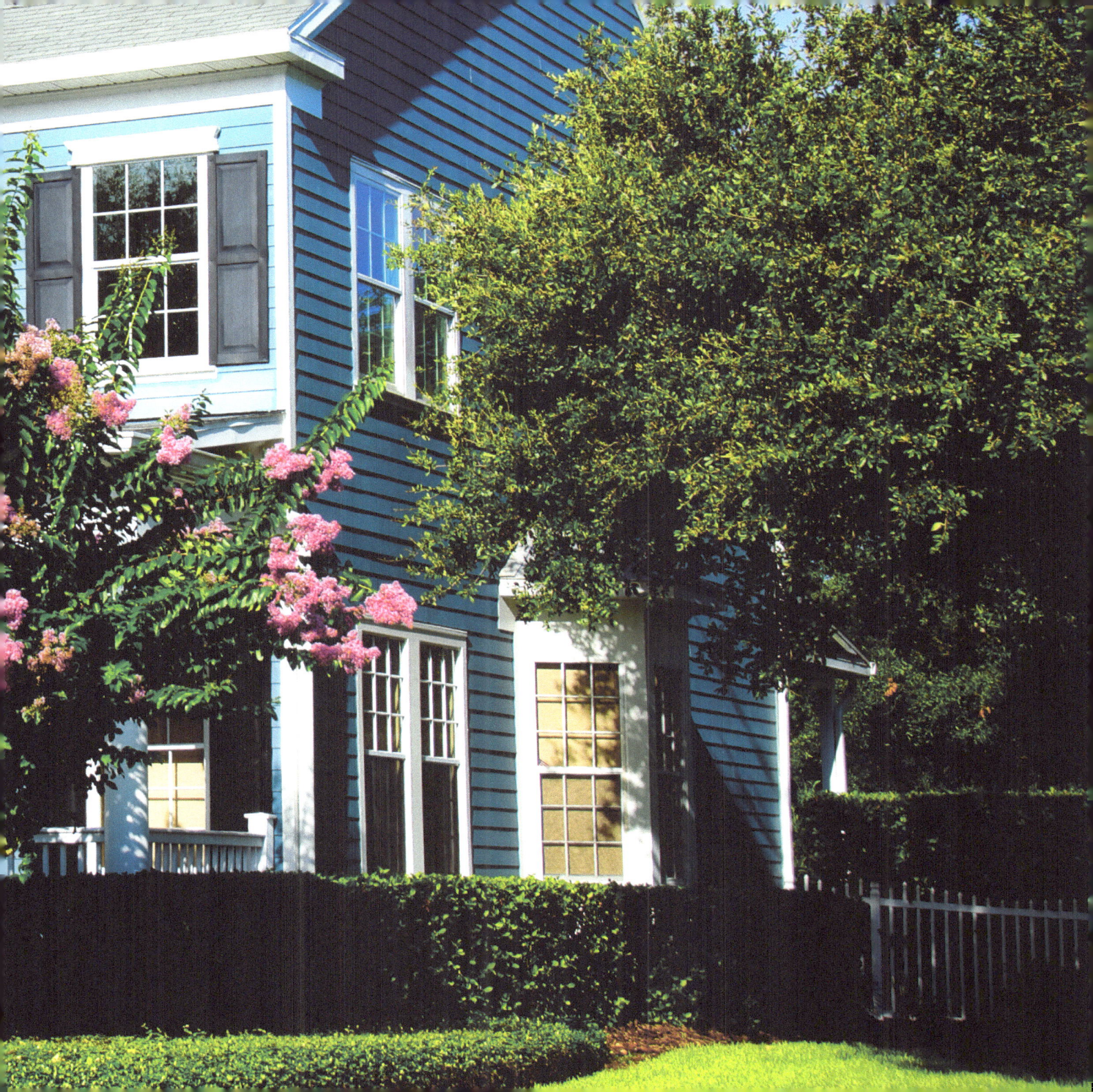

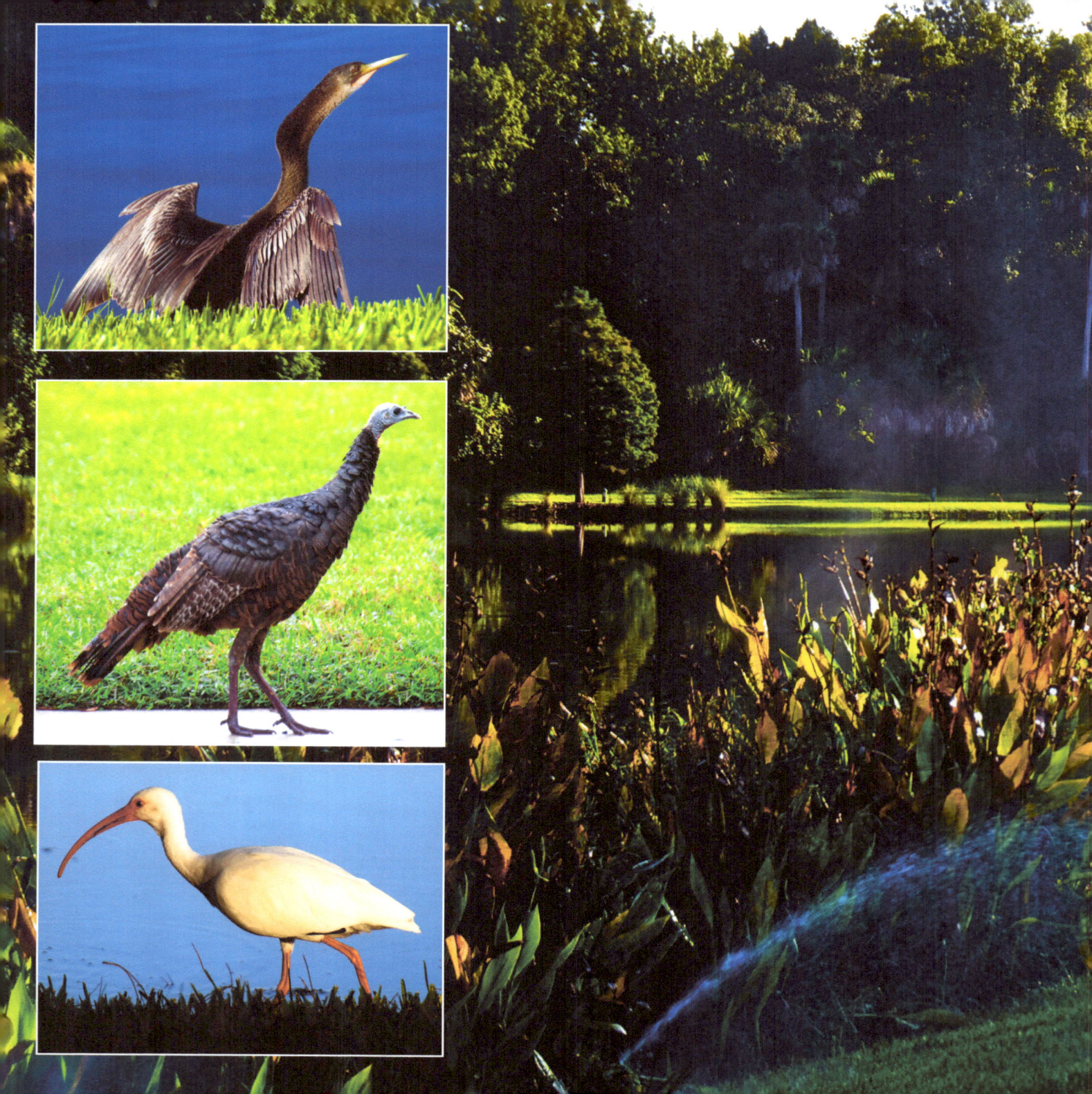

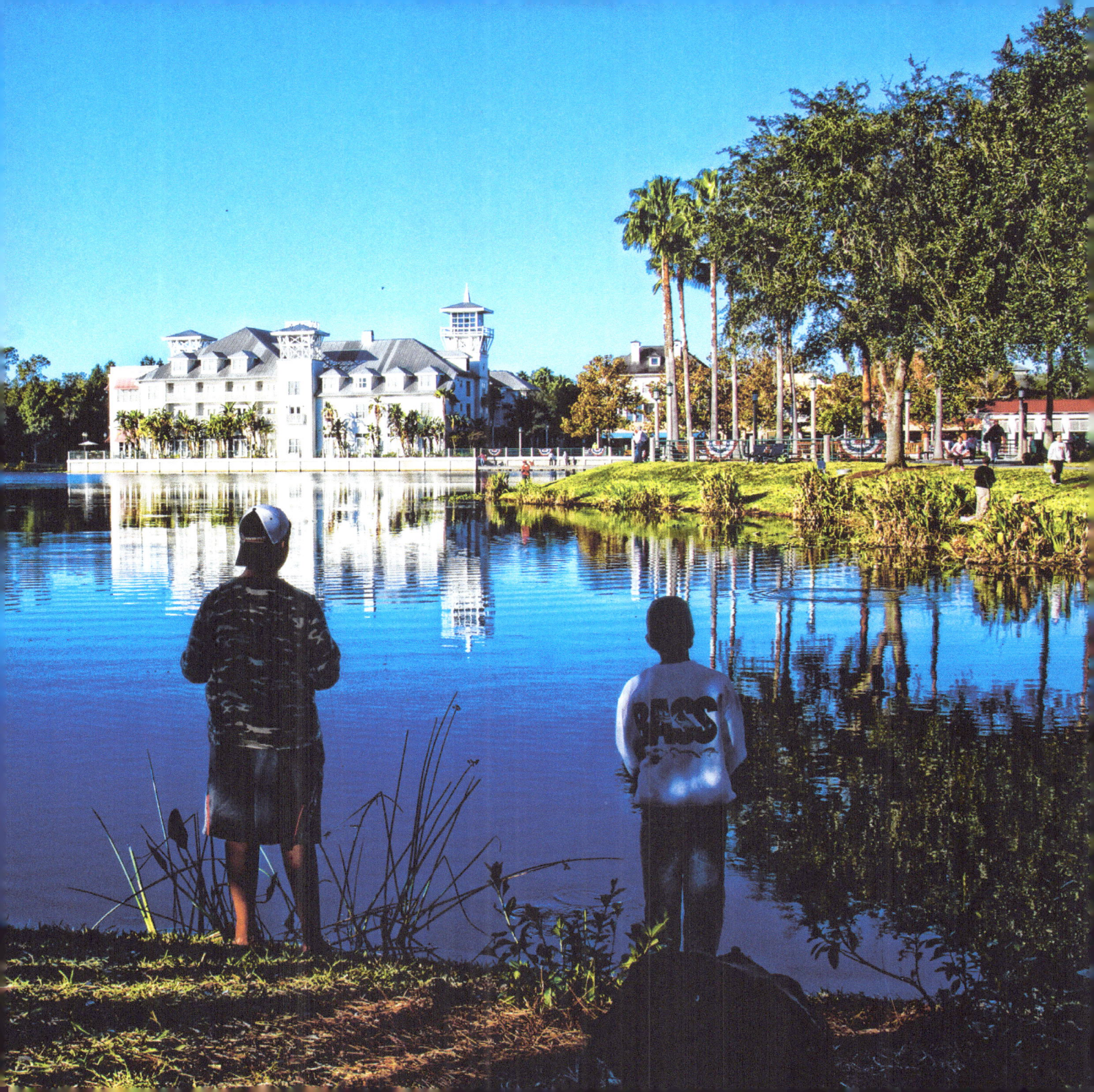

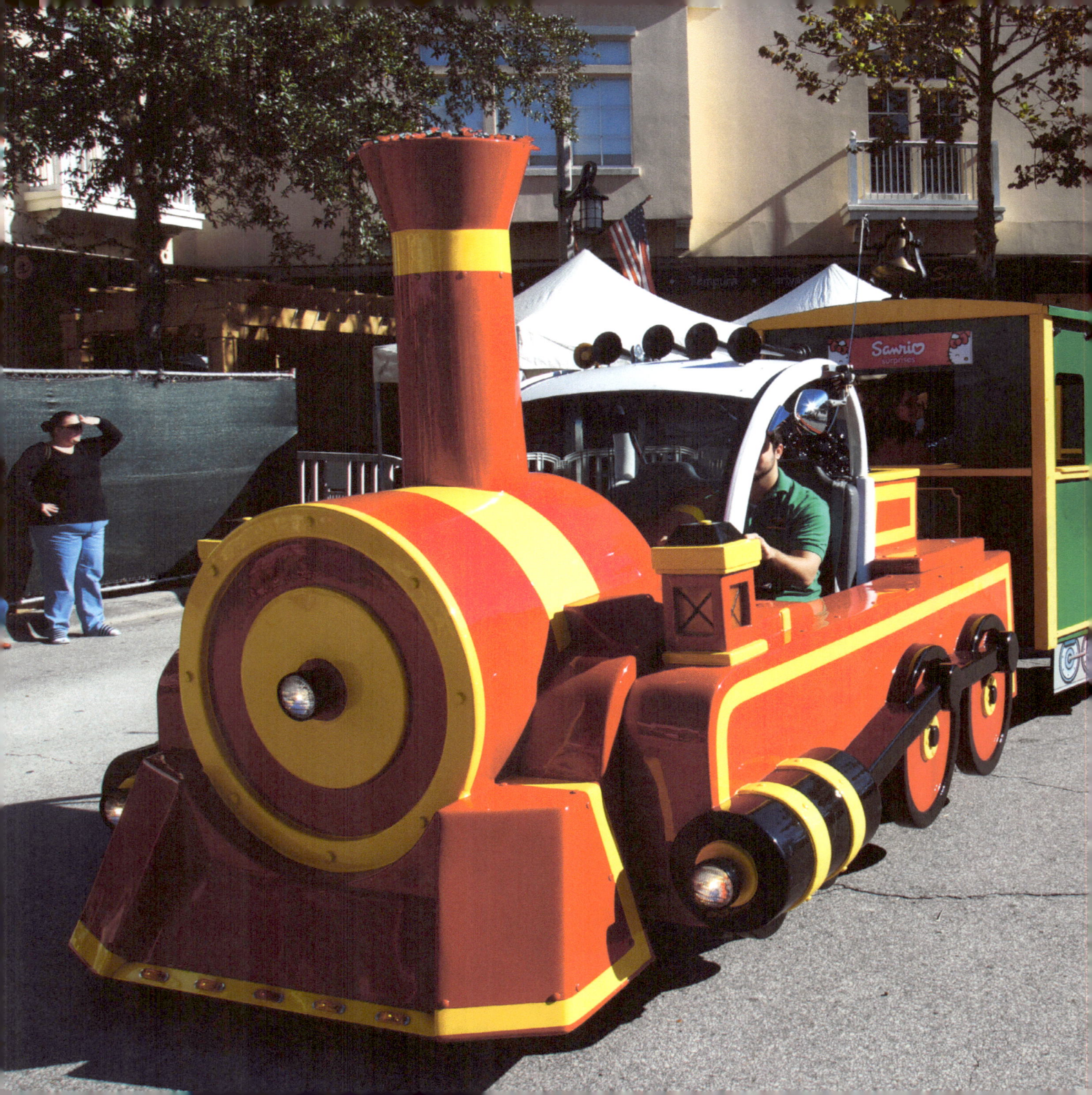

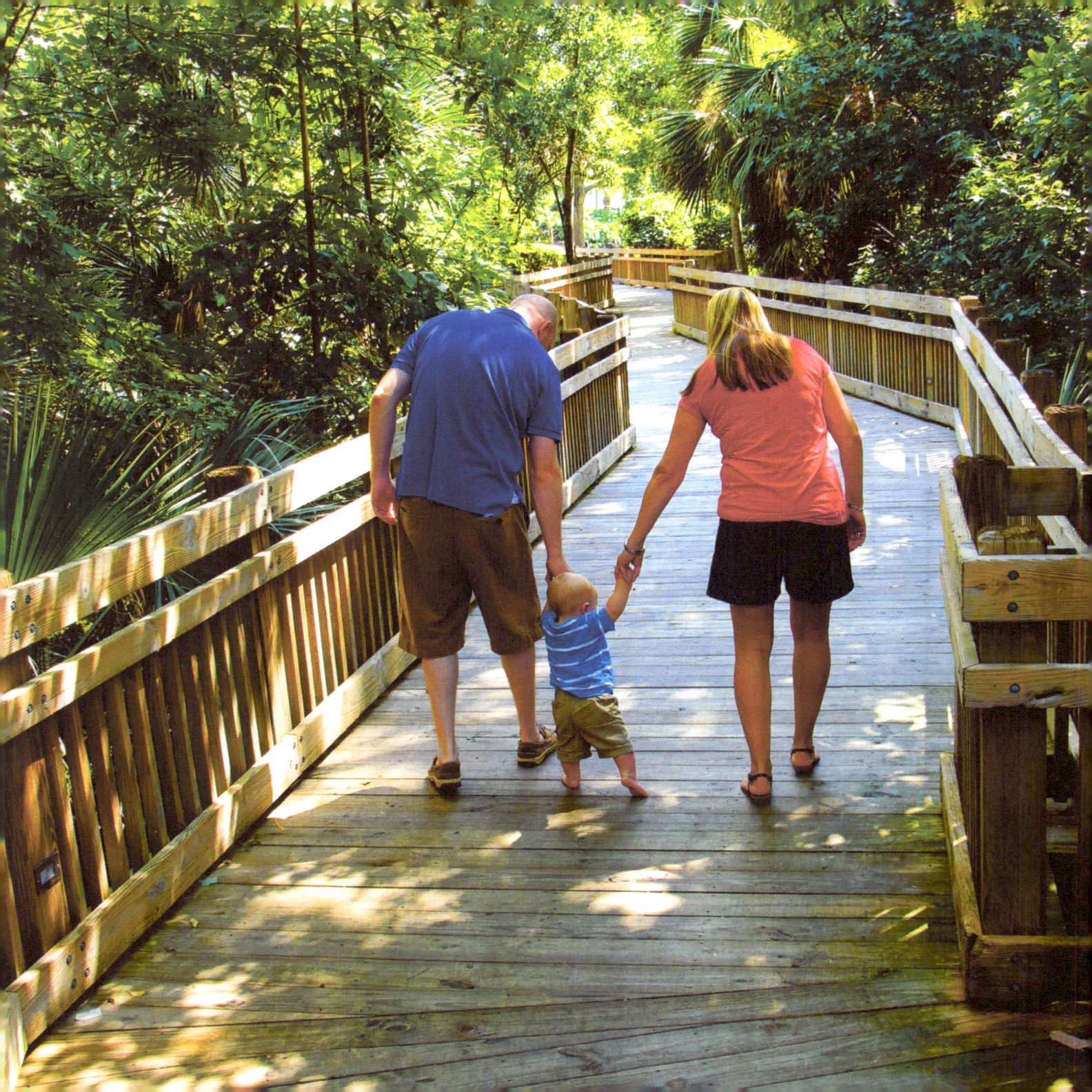

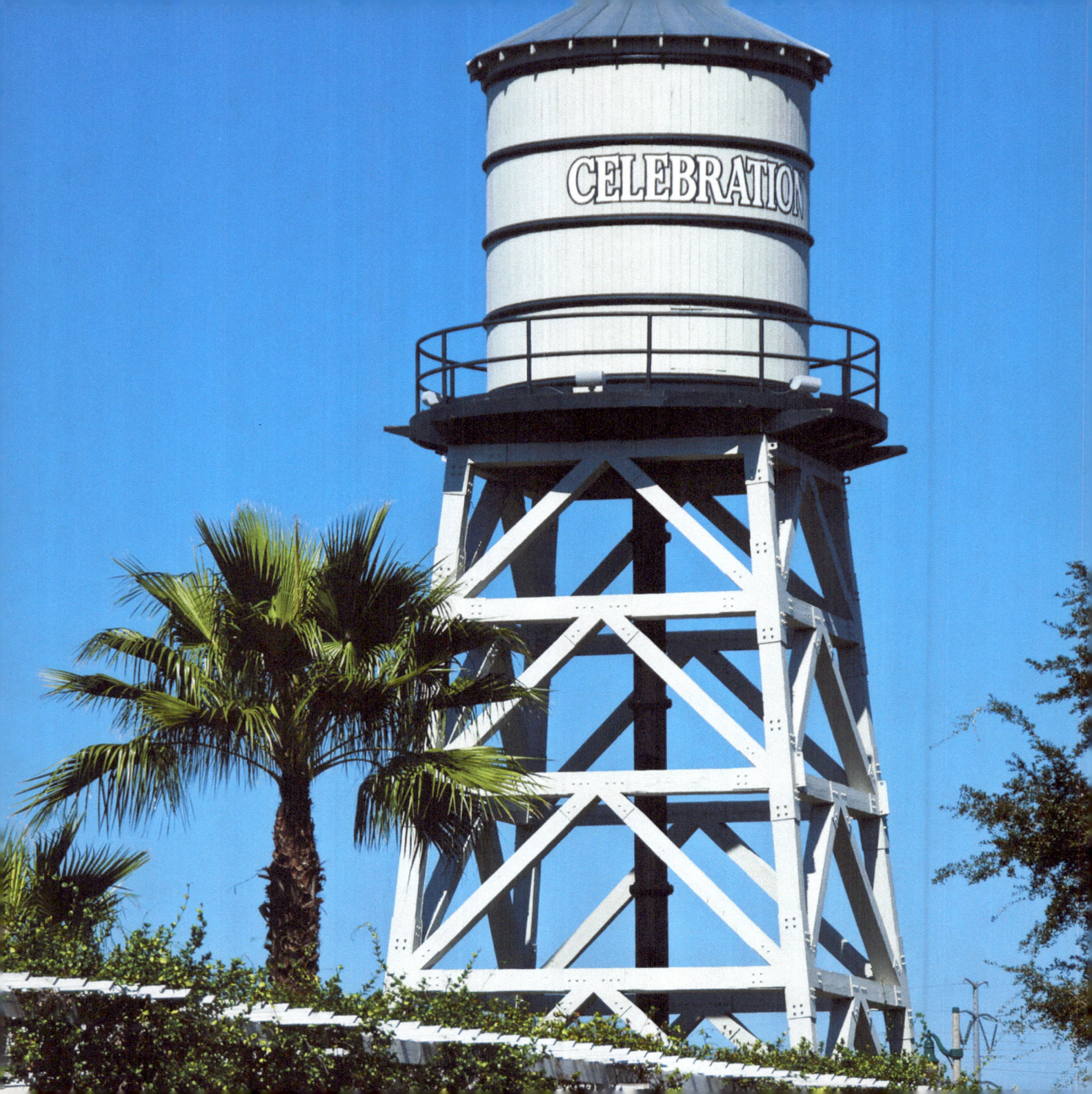

www.ingramcontent.com/pod-product-compliance
Lightning Source LLC
Chambersburg PA
CBHW051023180526
45172CB00002B/454